| LEISURE AND CULTURE DUNDEE ||
|---|---|
| C00783196X ||
| Bertrams | 09/06/2017 |
|  | £8.99 |
| CC | 567.915 |

# STEGOSAURUS

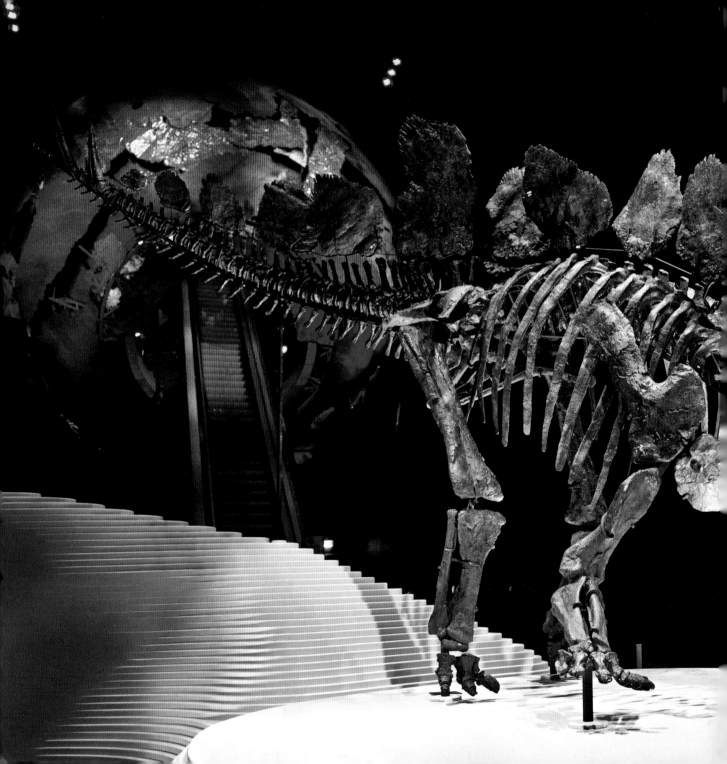

# STEGOSAURUS

An extraordinary specimen and
the secrets it reveals

Paul M Barrett

Published by the Natural History Museum, London

First published by the Natural History Museum
Cromwell Road, London SW7 5BD
© The Trustees of the Natural History Museum,
London, 2017

ISBN 978 0 565 09388 4

The Author has asserted his right to be identified as the Author of this work under the Copyright, Designs and Patents Act 1988.

All rights reserved. No part of this publication may be transmitted in any form or by any means without prior permission from the British Publisher.

A catalogue record for this book is available from the British Library.

Internal design by Bobby&Co Book Design
Reproduction by Saxon Digital Services
Printed by Toppan Leefung Limited, China

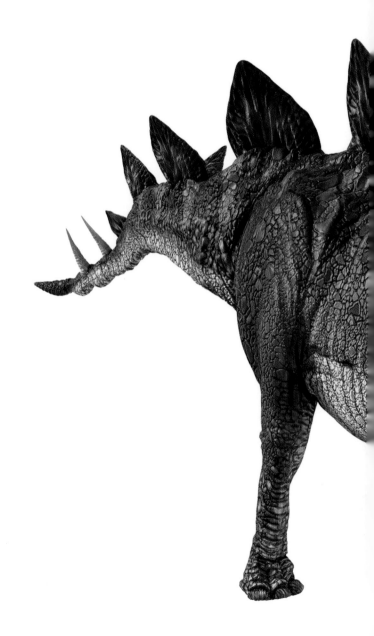

CHAPTER ONE
# AN UNEXPECTED DISCOVERY
6

CHAPTER TWO
# A BRIEF HISTORY OF STEGOSAURUS AND ITS RELATIVES
16

CHAPTER THREE
# A STEGOSAUR CALLED SOPHIE
36

CHAPTER FOUR
# STEGOSAUR LIFESTYLES
54

CHAPTER FIVE
# BUILDING A DINOSAUR DISPLAY
74

CHAPTER SIX
# THE SCIENCE OF SOPHIE
88

POSTCRIPT 104
ACKNOWLEDGEMENTS 105
FURTHER READING 107
PICTURE CREDITS 108

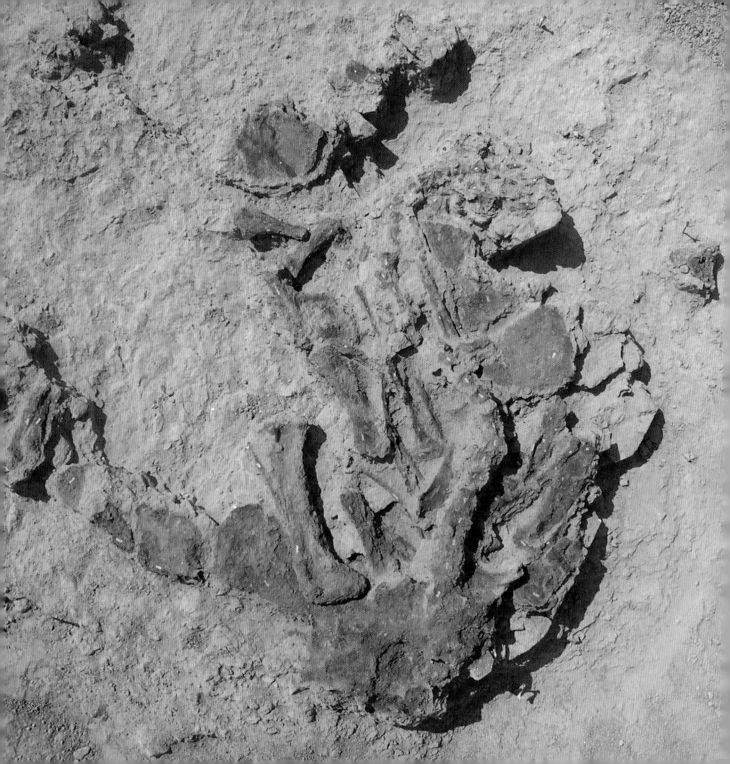

CHAPTER ONE

# AN UNEXPECTED DISCOVERY

THE TOWN OF SHELL LIES in a remote and sparsely populated part of northern Wyoming, USA. This small farming community has a population of fewer than 100 people and is surrounded by the rugged badlands and scrubby grasslands of the Bighorn Mountains. These landscapes would be familiar to any fan of Hollywood cowboy movies and support a number of large cattle ranches. During the summer temperatures are searingly hot, but deep cold and snow transform the area during the long, harsh winters. The name of the town seems surprising, given how far it is from the sea, but it relates not to living shellfish, but to the numerous fossil shells that have been found nearby.

Shells are not the only fossils that are common around Shell. This part of Wyoming has been visited by palaeontologists, the scientists that study fossils, for many decades and they have discovered much about the animals and plants that inhabited this region in the past. Their work has shown that around 150 million years ago, during the Late Jurassic period, the landscape would have looked very different from the way it appears today. Instead of the cows that now roam through the badlands, the most common animals in the area would have been a spectacular array of dinosaurs.

The badlands around Shell have been heavily eroded by wind and water over many centuries, so that the rocks are covered by only a thin layer of soil and are often exposed at the surface. Many of the rocks in the Shell area belong to a famous deposit called the Morrison Formation, a thick set of sandstones and mudstones that were laid down by large rivers that flowed through this region during the Late Jurassic period. The Morrison Formation extends across a vast swathe of what is now the western USA, covering over 1.5 million square kilometres (580,000 square miles), an area six times larger than the entire land surface of Great Britain. The best areas to see the Morrison Formation are in

**previous spread** The fossil remains of *Stegosaurus stenops* at Red Canyon Ranch Quarry discovery site.

Wyoming and Colorado, but these deposits also continue into the surrounding states and stretch from Montana and North Dakota in the north to New Mexico and Texas in the south. Sediments laid down by these ancient rivers now form spectacular hills and bluffs that vary in colour from light grey to deep red, and are often mottled green and purple. The Morrison Formation dates from around 156

**below** An artist's reconstruction of the dinosaur fauna from the Morrison Formation of the western USA, including *Diplodocus*, *Allosaurus* and *Stegosaurus*.

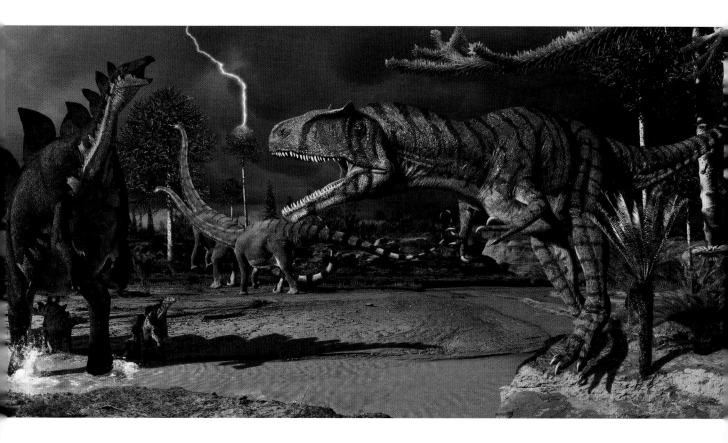

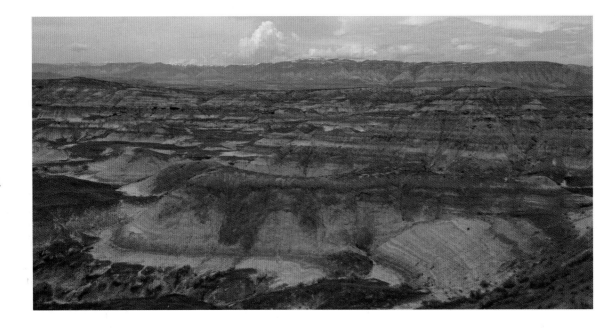

million to 147 million years ago; its rocks tell us about the Late Jurassic environments in which they formed, and they contain abundant evidence of the animals and plants alive at this time.

In July 2000, a professional fossil hunter, Robert (Bob) Simon, was digging for dinosaur bones in the Morrison Formation on Red Canyon Ranch, a cattle ranch approximately 25 kilometres (15 miles) north of Shell. During this trip he had been lucky enough to locate a well-preserved *Diplodocus* tail, with all of the individual tailbones found in their original positions, and he excavated this with

**above** A map of the Earth as it would have appeared during the Late Jurassic period. The Atlantic Ocean has not yet formed and the continents are still very close together.

the permission of the ranch owner, John Ed Anderson. This discovery proved that the area was rich in dinosaur bones and encouraged Bob to revisit the ranch to search for more.

During a trip in July 2003, Bob was working on another group of bones that he was excavating from a hillside close to his original *Diplodocus* discovery. His team had to use a bulldozer to remove some of the rock from the hillside to enlarge the dinosaur quarry and make removal of the large bones easier. As the bulldozer was available, Bob decided to move it further down the hill, away from the quarry, so that he could use it to explore another area for bones. A strong windstorm blew up as they moved the bulldozer, with the swirling dust making it difficult to see as they drove it downhill. As it travelled down, the blade of the bulldozer struck the side of the hill, causing a chunk of rock to fall. The next day Bob and his team returned to the site and noticed some strange coloration in the broken rock that had been hit by the bulldozer. On closer inspection, this strange coloured rock turned out to be fossil bone, and Bob realized that they had accidentally discovered a string of dinosaur vertebrae (backbones). These vertebrae continued from the damaged part of the hillside into the surrounding rock. As Bob's team were already busy excavating another large dinosaur fossil, which they needed to remove from their quarry before time ran out on their trip, they left these vertebrae in the hillside. However, they thought the vertebrae might be interesting, so before leaving they applied special preservative chemicals to their surfaces, helping to protect them so that they could be collected at a later date.

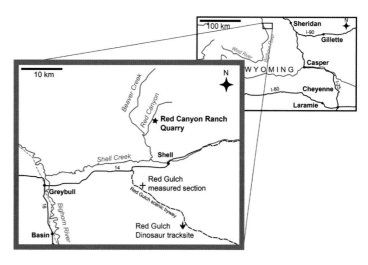

**above** This map shows the location of the Red Canyon Ranch Quarry, where 'Sophie' was found, which lies just outside of the town of Shell, Wyoming, USA.

**opposite** The Morrison Formation consists of colourful layers of alternating sandstones and mudstones, which erode to produce this spectacular scenery.

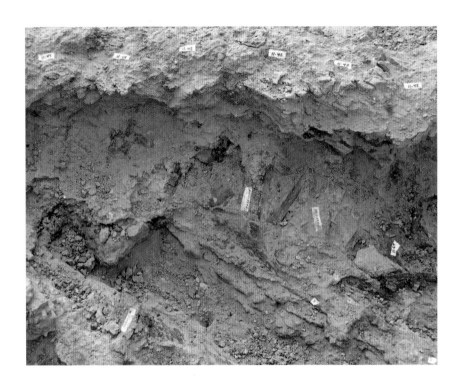

left A few backbones and ribs are poking out from the sandstone in this small excavation. They were the first sign that a dinosaur skeleton was lying just beneath the surface.

During the last few days of his 2003 field trip, Bob returned to the damaged hillside and realized that he could safely extract some of the bones, notably a string of small vertebrae that he recognized as coming from the end of a dinosaur tail. While excavating these bones Bob saw a thin layer of dark material going deeper into the hill. Although he wasn't sure whether this material was fossil wood or bone, Bob decided to apply more preservatives to its surface so that he could return the following year if the vertebrae proved to be of interest. As the weather was starting to deteriorate, Bob and his team had to abandon the site, and they covered the hillside to protect the remaining bones from the ravages of the harsh Wyoming winter.

Bob returned to his home in Virginia on the Atlantic Coast of the USA, far from the badlands of Wyoming. He had planned to continue work on some of his

other finds, which involved extracting dinosaur bones from the hard sandstone encasing them. However, the weather was to intervene in his work schedule again. Hurricane Isabelle struck the coast of the eastern USA in September 2003, destroying and damaging many homes and businesses in its path. It also knocked out power supplies for six million people, which included those in Bob's home town. During this time, Bob was unable to use the power tools he needed to continue his work, so he looked for another project to do. He remembered that the set of small vertebrae collected from the hillside were in much softer rock, so he decided to try and clean those using hand tools instead. After four days of careful work, slowly removing the soft sediment and treating the exposed bone with a variety of glues and preservatives, Bob had cleaned enough of the vertebrae to see them properly for the first time.

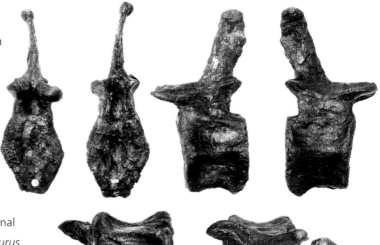

**below** Tail vertebrae like this one, shown in six different views, were the first parts of the skeleton to be excavated.

He was unfamiliar with the shape and reasoned that they must belong to a type of dinosaur he had not yet excavated. Henry Mendoza, a friend of Bob's and a volunteer at the Denver Museum of Natural History, happened to visit a few days later and saw the bones. Henry had experience of working with other Morrison Formation dinosaurs, and he suggested that the strange hexagonal tail vertebrae might be from a *Stegosaurus*. As other bones were known to be plunging into the ranch hillside back in Wyoming, Bob

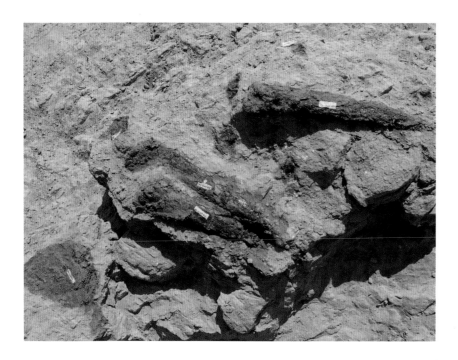

decided to go back in the hope of confirming this suggestion, but he had to wait until the end of winter before he could return.

Almost a year after the bulldozer had first grazed the hill, Bob returned to the same spot in July 2004 with a team of volunteers. They uncovered the site and began a thorough search. As the team expanded the quarry they started to uncover more and more bones. The discovery of long, conical bony tail spikes quickly confirmed Henry's idea: Bob's bulldozer mishap had accidentally led to the discovery of a *Stegosaurus*. The thin bone layers Bob had spotted in 2003 proved to be the edges of the distinctive armour plates found only in *Stegosaurus*. As the team worked quickly to remove the many tonnes of rock overlying the site, they revealed more and more of the skeleton. Many bones were present and most of them seemed to be preserved in their natural positions, showing how the skeleton fitted together. Two weeks of hard labour followed, until the team had uncovered

**above left** The discovery of these large, sharp tail spines confirmed that Bob Simon and his crew had found a *Stegosaurus*.

**above** *Stegosaurus* back plates have diamond-shaped outlines and thin bony frills around their upper edges. They are difficult to excavate as they are much more delicate than their large size suggests.

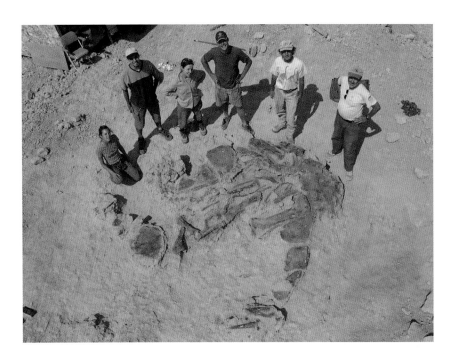

most of the skeleton. Only now did they realize that Bob had made a truly exceptional discovery: an almost complete *Stegosaurus* skeleton, one of only a handful ever found.

Bob's discovery is a landmark in a story that began with the life and death of this *Stegosaurus* individual 150 million years ago and which continues today. In the decade following that first glimpse of the skeleton in the rock, this amazing specimen has been excavated, cleaned, mounted and studied. On 4th December 2013, the *Stegosaurus* skeleton was unveiled to the public, forming a new permanent display in the Natural History Museum, London. This book tells the story of how this *Stegosaurus* came to London and the new information it gives us on the life and times of this iconic, but surprisingly poorly known, dinosaur.

**above** The excavation team found an almost complete skeleton, which they fully uncovered before taking the individual bones from out of the ground.

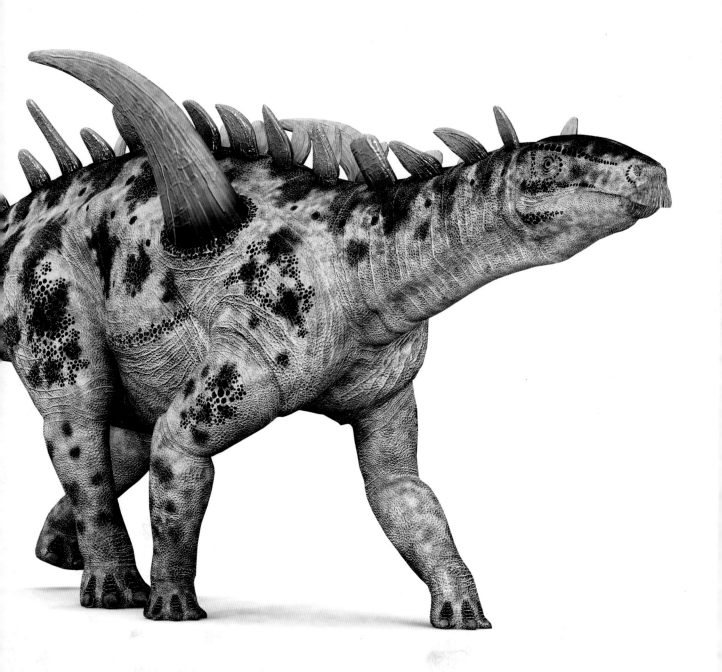

CHAPTER TWO

# A BRIEF HISTORY OF STEGOSAURUS AND ITS RELATIVES

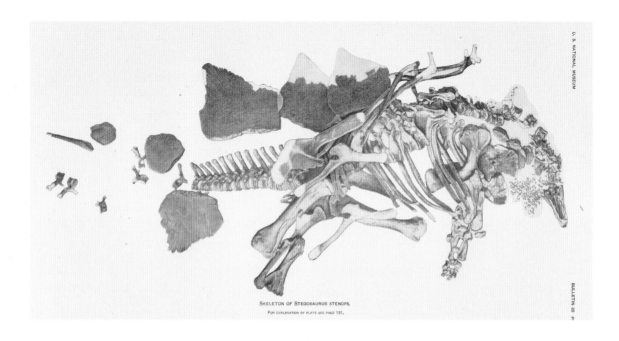

SKELETON OF STEGOSAURUS STENOPS.
FOR EXPLANATION OF PLATE SEE PAGE 131.

**STEGOSAURUS IS ONE** of the most charismatic dinosaurs and is instantly recognizable thanks to its set of extraordinary diamond- and triangular-shaped back plates, as well as the famous spines on the tail. It has appeared in numerous fictional roles, such as Sir Arthur Conan-Doyle's adventure story *The Lost World* and in the *Jurassic Park* movies, as well as being one of the 'standard' dinosaurs portrayed in sets of dinosaur toys, museum displays, non-fiction books and TV documentaries such as *Walking with Dinosaurs*. *Stegosaurus* has no close counterpart among living animals, and its fantastic appearance is probably the main reason for its fame among dinosaur fans and the general public. However, this familiarity is misleading, as scientists know surprisingly little about *Stegosaurus* biology. The reason for this is that remains of *Stegosaurus* are rare: only a handful of skeletons have been found, and none of these has been complete. In addition, some of the best skeletons, such as those housed in the National Museum of

**above** An illustration of the almost complete holotype specimen of *Stegosaurus stenops*, housed in the Smithsonian Institution, Washington, D.C., USA. C. W. Gilmore included this image in his description of *Stegosaurus*.

**previous spread**
*Gigantspinosaurus sichuanensis*, a stegosaur from China.

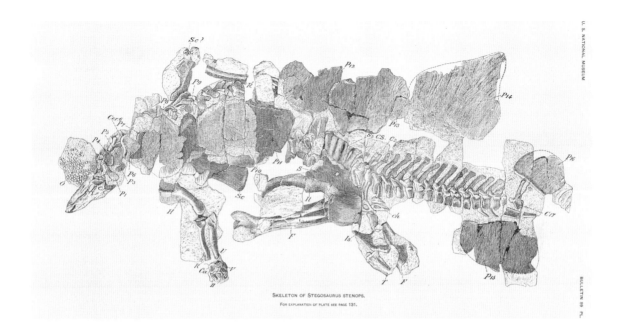

above The reverse side of the Smithsonian specimen of *Stegosaurus stenops* includes many elements of the skeleton, including some beautiful back plates, but is still fully embedded in rock.

Natural History (Smithsonian Institution) in Washington, D.C. and in the Denver Museum of Natural History and Science, Denver, are preserved as flat slabs that prevent three-dimensional reconstruction of the whole animal. Other isolated bones have also been found, but in general the fossil record of *Stegosaurus* is much less complete than that of other famous dinosaurs such as *Tyrannosaurus* and *Diplodocus*.

Almost all *Stegosaurus* specimens come from the Late Jurassic Morrison Formation in the USA and are known mainly from Colorado and Wyoming, with rare finds in Utah and Oklahoma. The first material was found in a quarry near the small town of Morrison, Colorado and was brought back to the Peabody Museum of Natural History, part of Yale University, for study. It consisted of some broken vertebrae, part of a back plate and fragments of other bones. It was named *Stegosaurus armatus*, meaning 'armoured roof lizard' by the famous American

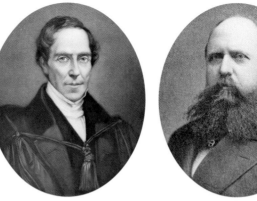

palaeontologist Othniel Charles Marsh. In this paper, which was published in 1877, Marsh also noted that *Stegosaurus* had an unusual mix of features not seen in any other reptile group. Indeed, he thought it was so unique that it could not be assigned to any known group of reptiles, living or extinct. To solve this problem he proposed a new group, Stegosauria, to receive it.

Although Marsh was responsible for naming Stegosauria, he was not the first scientist to describe stegosaur fossils. That honour probably fell to an Englishman – Gideon Mantell – a doctor who made many of the earliest dinosaur discoveries from the tranquil countryside of southern England, far from the American badlands. In 1848, Mantell published a short article on a small piece of lower jaw, lacking teeth, which he had found in the hard sandstone of a quarry near Cuckfield, Sussex. This fossil, which we now know to have dated from the Lower Cretaceous period (and which is around 135 million years old), was named *Regnosaurus northamptoni* and is housed in the collections of the Natural History Museum, London. Although scientists have debated the exact identification of *Regnosaurus*, it seems most likely that it was a stegosaur, although the single, fragmentary specimen available makes it hard to be sure. Nevertheless, *Regnosaurus* has a strong claim to be the earliest named stegosaur material in the world, as it was named 29 years before the group was formally recognized.

**above** Othniel Charles Marsh (1831–1899) named 80 species of dinosaurs, including many from the Morrison Formation, and was the person who named *Stegosaurus* in 1877.

**above left** Gideon Mantell (1790–1852) was one of the first dinosaur palaeontologists. He named *Regnosaurus*, an English stegosaur, in 1848, long before stegosaurs were recognised as distinct dinosaur group.

However, even *Regnosaurus* cannot claim to be the first stegosaur fossil found. Half a world away, in 1845, engineers working near the Bushman's River, near Grahamstown, South Africa discovered numerous bones during the course of their construction work. These were sent to London for the attention of Sir Richard Owen, the leading anatomist and palaeontologist of his time, who later became the first Director of the Natural History Museum. Although Owen received the fossils in either the late 1840s or early 1850s, he did not publish on the material until much later. In 1876, he finally described these bones and suggested that they all belonged to an animal he named *Anthodon serrarius*, which he identified as a pareiasaur, a type of large, armoured, plant-eating reptile from the Permian Period (299–252 million years ago). Owen had made a mistake, however: he had mixed two sets of bones from different places and differently aged rocks together. Some of the bones he described were genuinely from a pareiasaur and were of Permian age (and are still called *Anthodon*), but the others were from much younger rocks that dated to the Lower Cretaceous period. These younger bones included part of a skull, which was recognized as a dinosaur by Scottish-born South African palaeontologist Robert Broom in 1910 and named *Palaeoscincus africanus*. However, the name *Palaeoscincus* was in use for another type of dinosaur, an armoured ankylosaur from North America, so in 1929 it received yet another name – this time one that stood the test of time – *Paranthodon africanus*. The scientist who suggested this new name, eccentric and flamboyant Transylvanian aristocrat Baron von Nopcsa, was also the first person to realize that *Paranthodon* was a stegosaur. So, in spite of its complicated history, *Paranthodon* was actually the

**above** Founder and first director of the Natural History Museum, Sir Richard Owen (1804–1892) coined the name 'Dinosauria' in 1842 and he also named stegosaurs from England and South Africa.

**opposite** This partial lower jaw is the only known specimen of the Early Cretaceous stegosaur *Regnosaurus* from southern England, the first member of the group to be named scientifically.

first stegosaur fossil to be discovered (though it was not named and recognized as such until much later) and it is also one of the first dinosaurs to have been named from the entire African continent.

Two other discoveries from southern England also predated Marsh's naming of *Stegosaurus*. The first of these was found in the Lower Cretaceous rocks of a quarry near Potton, Bedfordshire, England. As with *Regnosaurus*, only a single, rather incomplete, bone was recovered. It was sent to the Sedgwick Museum at Cambridge University and described by their resident expert Harry Govier Seeley, a palaeontologist famous for his work on flying reptiles (pterosaurs). Seeley thought that this unusual bone was part of the skull of a large lizard, and he named it *Craterosaurus pottonensis* in 1874. However, further work showed that it was actually part of a large and unusual vertebra, which was finally recognized as that of a stegosaur in 1981. The second discovery was much more impressive: a huge, complete pelvis, together with numerous vertebrae, leg bones and one large tail spine. This partial skeleton was found in a brickpit near Swindon, Wiltshire in clays dating from the Late Jurassic period that are similar in age to the rocks yielding *Stegosaurus* fossils in the USA. Sir Richard Owen provided the first description of this material, which he named *Omosaurus armatus* in 1875. This ranks as the first detailed description of a stegosaur skeleton ever published, and the specimen is currently on display in the Natural History Museum, London. Unfortunately, as had happened with *Paranthodon*, the name of the animal had to be changed as it was later realized that the name *Omosaurus* had already been used for another extinct reptile, so this animal was renamed *Dacentrurus armatus*, the name it still bears today.

**above** *Paranthodon africanus* is a South African species of stegosaur that is known only from this incomplete skull, which consists of the snout and a few teeth.

**left** The hip region and hind leg of the English stegosaur *Dacentrurus*. This specimen was named by Sir Richard Owen and can be seen on display in the Natural History Museum.

Much of the confusion surrounding the early naming of stegosaurs is due to the fragmentary state of many of the early finds, which were very difficult for scientists to study, as they had only a handful of bones to guide their interpretations. However, the years following Marsh's naming of *Stegosaurus* saw a boom in new discoveries, which finally started to include more complete skeletons. In the hunt for spectacular display specimens, numerous expeditions were sent to the American West, financed by the great museums and universities of New York, New Haven, Washington, D.C. and Pittsburgh, and these led to discoveries of many more dinosaur quarries in the Morrison Formation. Some of these yielded new *Stegosaurus* material. Many of the specimens excavated at that time were initially described either as new species of *Stegosaurus* or as close relatives, with a variety

of new names appearing in scientific articles, including *Hypsirophus seeleyanus* and *Diracodon laticeps*, among many others. However, the differences between all of these new specimens were very minor and the discovery of more complete skeletons began to show that many of these features were due to nothing more than slight differences in how the animals had grown, or variation in how well each bone had been preserved. As scientists re-studied the material and made careful comparisons between all the available finds, most of these names were abandoned.

*Stegosaurus stenops* was named by Marsh in 1887 on the basis of an almost complete skeleton with an excellent skull, which lacks some of the limb material, tail vertebrae and plates. It was found in a very hard layer of sandstone within the

**above** A complete, three-dimensionally preserved skull of *Stegosaurus stenops*, which forms part of the holotype skeleton housed in the Smithsonian Institution, Washington D.C., USA.

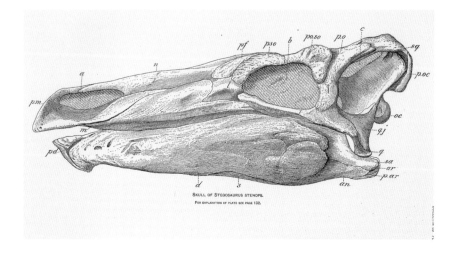

**left** A drawing of the Smithsonian's *Stegosaurus stenops* skull, taken from C. W. Gilmore's detailed description, identifying the different bones in the skull and how they are connected to each other.

Morrison Formation, in a quarry near Garden Park, around 10 miles northeast of Cañon City, Colorado. This specimen is now housed in the Smithsonian Institution and is the only *Stegosaurus stenops* skeleton to have been fully described by scientists so far. As a result, many reconstructions of *Stegosaurus* and most of the work that has been carried out on its biology have been heavily based on this single skeleton. The most comprehensive description of this individual was published in 1914 by Charles W. Gilmore, the Smithsonian's resident dinosaur expert at the time. Perhaps surprisingly, this description remained the only really detailed scientific study of *Stegosaurus* anatomy for over a century. This situation reflects the fact that only a few additional *Stegosaurus* skeletons have been uncovered since Gilmore's time. It also highlights the excellent standard of Gilmore's work: he did such a good job in 1914 that there was little need to update the description for much of the twentieth century.

New *Stegosaurus* specimens continued to be found during the twentieth and twenty-first centuries, but few of these have been described scientifically. Several additional partially complete skeletons have now been excavated from quarries in Wyoming and Colorado. Perhaps the most complete of these is that in the Denver Museum of Natural History and Science, although as the skeleton is crushed and flattened it has not been the subject of thorough analysis. Other *Stegosaurus* skeletons from this area were exported from the USA to Switzerland and can be seen on public display in the Sauriermuseum, which is located in the small town of Aathal, just outside the city of Zürich. Other *Stegosaurus* material was recently found in Portugal, suggesting that it was a rare example of a trans-Atlantic dinosaur. As the Atlantic Ocean did not exist during the Late Jurassic, North America and Europe were much, much closer to each other than they are today, enabling dinosaurs to move back and forth between these regions. Some other

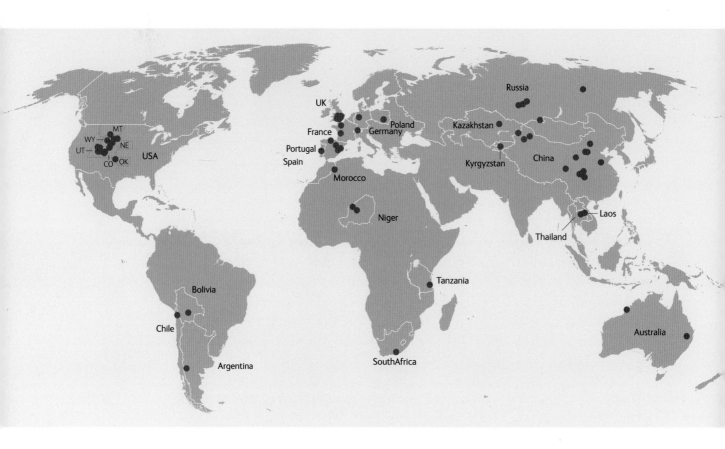

above This map shows the places where stegosaur fossils (including both bones and footprints) have been found around the world.

classically North American dinosaurs, such as the carnivores *Allosaurus* and *Torvosaurus*, are also known from Portugal.

Two other skeletons from the Morrison Formation found their way to museums in Japan: the National Science Museum in Tokyo and the Hayashibara Museum of Natural History in Okayama. The palaeontologists who worked on the Hayashibara specimen, which includes the skull and body but lacks most of the limbs and many plates, noted that it differed in several ways from the *Stegosaurus stenops* skeletons in the Smithsonian Institution and the Denver Museum, particularly in various details of the shapes and numbers of the vertebrae and in

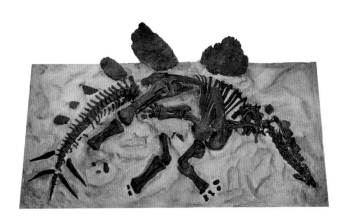 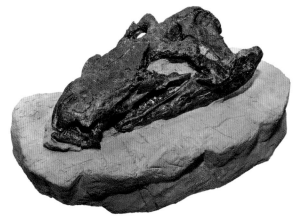

above A spectacular skeleton and skull of the Morrison stegosaur *Stegosaurus mjosi*, which is also known as *Hesperosaurus mjosi* by some scientists.

the shapes of the plates. For example, in *Stegosaurus stenops* the back plates are usually taller than long, whereas in the Hayashibara skeleton the plates are longer than they are tall. These differences suggested that the Hayashibara skeleton belonged to a different type of stegosaur, which was named *Hesperosaurus mjosi* and described by Kenneth Carpenter and his colleagues in 2001. However, other stegosaur specialists have questioned whether the differences between *Stegosaurus stenops* and *Hesperosaurus mjosi* are great enough to justify making them members of different genera: they take a slightly different view and regard the Hayashibara skeleton as a new species of *Stegosaurus*, *Stegosaurus mjosi*. As a result, scientists currently recognize two species of *Stegosaurus* from North America: *Stegosaurus stenops* and *Stegosaurus mjosi*.

Recently, another type of stegosaur was recognized in the Morrison Formation. During his work on *Stegosaurus*, Charles W. Gilmore described an incomplete skeleton that had been collected in 1908 from near Alcova, a small town in Wyoming, USA. This skeleton included some of the ribs, the hip region, part of the right leg and a long string of tail vertebrae. It also included four tail spines, which were so large that Gilmore thought that the specimen represented a new species of *Stegosaurus*, which he named *Stegosaurus longispinus* in 1914. The skeleton was stored at the University of Wyoming, but it was destroyed during an accident in the late 1920s, when hot water pipes in the museum's ceiling burst and caused the bones to crumble apart. As a result, few palaeontologists have

considered *Stegosaurus longispinus* in their studies since, and, when they did mention it, they usually regarded the specimen as a slightly unusual example of *Stegosaurus stenops*. Luckily, plaster casts of some of the bones survived in other museums and photographs of the specimen were also preserved. Recently, a detailed examination of these records revealed that Gilmore had been right; there were definite differences between the *Stegosaurus longispinus* skeleton and those of the other *Stegosaurus* species. In fact, these differences were striking enough that in 2015 palaeontologists Peter Galton and Kenneth Carpenter removed it from *Stegosaurus* and proposed a new name for this specimen: it is now known as *Alcovasaurus longispinus*.

The early finds in South Africa, the UK and USA were followed by a set of new discoveries in other parts of the world. These led to a gradual increase in the total number of known stegosaur species through the twentieth century and into the twenty-first century. East Africa was to provide the first new stegosaur species of the twentieth century, following a series of major dinosaur expeditions carried out by German scientists on and around a low hill near the village of Tendaguru, Tanzania between 1907 and 1913. These expeditions often lasted many months and sometimes employed hundreds of local people to dig the dinosaur quarries and remove the bones. The rocks forming Tendaguru Hill were deposited at around the same time as those of the Morrison Formation in the USA, so are also of Late Jurassic age. Excavations unearthed thousands of dinosaur bones, including those of gigantic sauropod dinosaurs, such as *Giraffatitan* and *Dicraeosaurus*, and the meat-eater *Elaphrosaurus*. Among these finds were many bones belonging to a new stegosaur species that was named *Kentrosaurus aethiopicus* by Edwin Hennig in 1915. Unfortunately, none of these bones definitely formed part of the same skeleton, but luckily the sheer number of bones available (numbering many

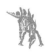

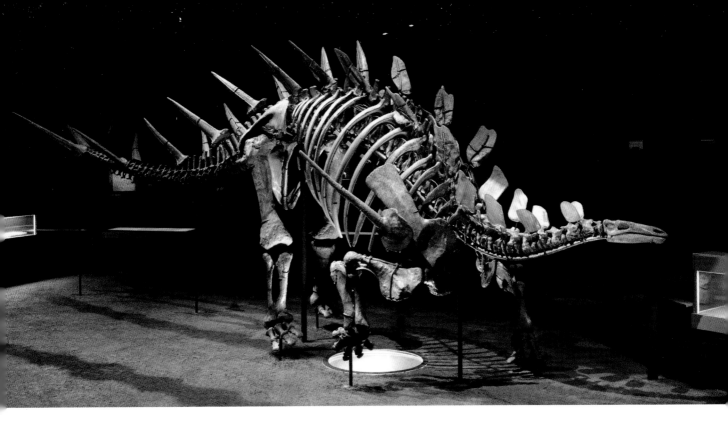

above A mounted skeleton of *Kentrosaurus aethiopicus* in the Museum für Naturkunde, Berlin. It is composed of bones from several different individuals that were all discovered at Tendaguru, Tanzania.

hundreds) included several partial skulls and numerous limb bones and vertebrae that allowed a good picture of *Kentrosaurus* to emerge.

During the middle part of the twentieth century the focus of stegosaur research shifted again – this time to remote areas of rural China. During the 1940s, Chinese palaeontologists under the direction of C. C. Young started to discover rich dinosaur beds in Sichuan Province, a region in the subtropical southwestern corner of the country. These beds were originally thought to be Late Jurassic in age and laid down at a similar time to those yielding stegosaurs in the USA and Tanzania. However, more recent work suggests that these Chinese deposits were actually laid down much earlier and geologists now think that they are more likely to date from the Middle Jurassic. The first stegosaur to emerge from Sichuan was named *Chialingosaurus kuani* by C. C. Young in 1959. Unfortunately, although palaeontologists agree that the bones of *Chialingosaurus* belonged to a stegosaur,

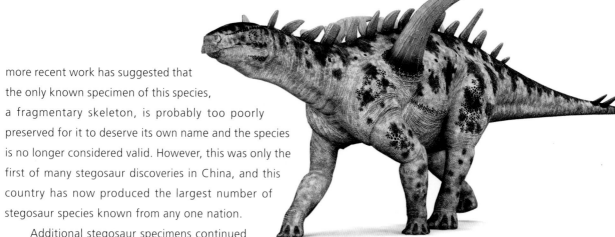

more recent work has suggested that the only known specimen of this species, a fragmentary skeleton, is probably too poorly preserved for it to deserve its own name and the species is no longer considered valid. However, this was only the first of many stegosaur discoveries in China, and this country has now produced the largest number of stegosaur species known from any one nation.

Additional stegosaur specimens continued to be unearthed from the Middle Jurassic rocks of Sichuan by a former student of C. C. Young, Chinese dinosaur expert Dong Zhiming. These included *Tuojiangosaurus multispinus*, named in 1977, and *Chungkingosaurus jiangbeiensis*, named in 1983. A third stegosaur found in these beds more recently was named *Gigantspinosaurus sichuanensis* by Ouyang Hui in 1992. Each of these species is known from only one or two partially complete skeletons, but although they all lived at the same time and in the same area many differences between the skeletons show that they belonged to distinct species that can be clearly separated from each other. In 1983, Professor Dong named another Sichuan stegosaur – *Huayangosaurus taibaii*. Unlike the other Chinese stegosaurs, *Huayangosaurus* is known from an almost complete and beautifully preserved skeleton, along with remains of several other individuals. The completeness of *Huayangosaurus* and its Middle Jurassic age have made it an important animal in discussions over stegosaur origins and evolution.

Following the first discoveries in Sichuan, other regions of China also produced stegosaur fossils. These included *Wuerhosaurus homheni*, from the Late Jurassic of Xinjiang, a vast desert region in the northwest of China that has since

above *Gigantspinosaurus sichuanensis* is one of several stegosaurs from the Middle Jurassic of Sichuan, southwest China. It is characterized by a huge shoulder spine that is much larger than those in other stegosaurs.

yielded abundant dinosaur fossils. Named by Dong Zhiming in 1973, *Wuerhosaurus* is a controversial animal: some palaeontologists think that it deserves a name in its own right, while others have suggested that the remains are so similar to those of *Stegosaurus* that it should be regarded as a Chinese species of *Stegosaurus*, and known as *Stegosaurus homheni*. If this suggestion is correct, *Stegosaurus* would be the only stegosaur known from more than one continent, with a distribution spanning North America, Europe and East Asia. The most recently named stegosaur from China is *Jiangjunosaurus junggarensis,* which is also from the Late Jurassic of Xinjiang, though from a region some distance away from that in which *Wuerhosaurus* was discovered. Known from a single partially complete skeleton including a beautiful skull, *Jiangjunosaurus* was named in 2007 by Jia Chengkai and colleagues. It was found in spectacular badlands that are probably more famous as being the area in which parts of the movie *Crouching Tiger, Hidden Dragon* were filmed. As the Chinese word for dinosaur ('konglong') means 'terrible dragon' it seems very appropriate that dinosaur fossils should be found in the area where this particular movie was shot. Finally, several other stegosaur

**below** This skeleton of the Chinese stegosaur *Huayangosaurus taibaii* is almost complete and has provided scientists with important information on early stegosaur evolution.

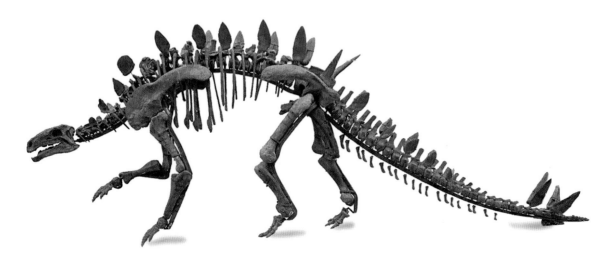

species have also been named from China (e.g. *Monkonosaurus lawulacus* from Tibet and *Wuerhosaurus ordosensis* from Inner Mongolia), but the majority of palaeontologists agree that these species cannot be properly defined and that the names should be regarded as invalid. However, even if we disregard these invalid species names, China has yielded a total of six valid stegosaur species, which is almost half of the worldwide total for the group Stegosauria as a whole.

The only other area regularly producing stegosaur fossils is western Europe, with remains from France, Spain and Portugal as well as the UK. Some of these finds, such as those from the latest Jurassic–earliest Cretaceous of Spain, probably belong to *Dacentrurus*, but other specimens are too fragmentary to assign to a particular stegosaur species. Nevertheless, one other species from Europe completes the list of stegosaurs known from around the world. This animal, based on a partial skeleton found near Peterborough, England, was originally named *Stegosaurus priscus* by Baron von Nopcsa in 1911. The specimen was found in a clay pit, by quarrymen that were mining the clay for brickmaking. It consists of vertebrae, limb bones, hip bones and some armour. It is of Middle Jurassic age and the geologically oldest representative of the group in Europe. More recent work showed that this specimen differs from North American species of *Stegosaurus* in many respects and so a new name, *Loricatosaurus priscus*, was proposed for this animal by Susannah Maidment in 2008. A second specimen of *Loricatosaurus* is known from similarly aged rocks in Normandy, France.

**below** *Loricatosaurus priscus* is represented by a single partial skeleton from southern England, which includes this vertebra and piece of armour among other remains.

It was recently suggested that a skeleton excavated from the Late Jurassic deposits of Lourinhã, Portugal might represent a new European species. This specimen, which includes a partial skull and the front half of a skeleton, was named *Miragaia longicollum* by Octávio Mateus and colleagues in 2009. However, more recent work suggests that the *Miragaia* skeleton is actually identical to those of *Dacentrurus*: as a result, *Miragaia* is no longer considered a distinct species by palaeontologists.

Fragmentary stegosaur bones have been noted from other parts of the world, including Argentina, India, Kyrgyzstan, Madagascar, Russia and Thailand. The bones found in central Asia and Thailand are very similar to those of other stegosaurs, but they are too incomplete to be recognized as new species. However, finds from some of these other areas, such as Argentina, India and Madagascar, have been questioned and it is likely that many of them belong to

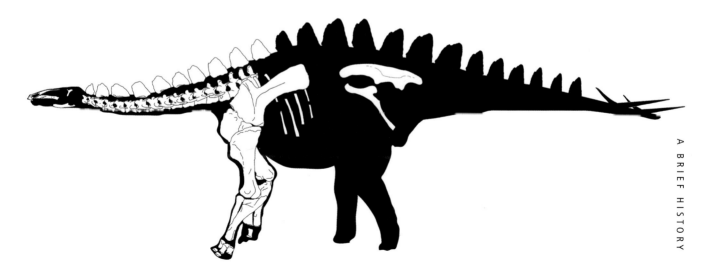

**below** This partial skeleton from Portugal was named *Miragaia*, but is now thought to be another *Dacentrurus*. It confirms the presence of this species in the UK, Spain and Portugal.

other dinosaur groups or other types of extinct reptile. For example, a set of very fragmentary bones found in the Late Cretaceous of India were identified as a possible stegosaur and named *Dravidosaurus blandfordi* in 1979. This was a potentially important find as this animal lived at a time much later than all other stegosaurs, which were thought to have gone extinct during the early part of the Cretaceous Period. However, further work on this material suggested that it was not a stegosaur, or even a dinosaur, but probably a type of long-necked marine reptile called a plesiosaur. This illustrates how even experienced palaeontologists can sometimes make mistakes when working with very difficult, broken material.

In addition to the fossilized bones of stegosaurs, palaeontologists have identified possible stegosaur footprints from sites in Australia, Morocco, Poland and the USA, spanning the Early Jurassic to Early Cretaceous.

The fossil record of stegosaurs is small in comparison to that of most other dinosaur groups. When all of the abandoned names for fragmentary fossils are ignored, palaeontologists currently recognize a total of only 13 valid stegosaur species (*Alcovasaurus longispinus*, *Chungkingosaurus jiangbeiensis*, *Dacentrurus armatus*, *Gigantspinosaurus sichuanensis*, *Huayangosaurus taibaii*, *Jiangjunosaurus junggarensis*, *Kentrosaurus aethopicus*, *Loricatosaurus priscus*, *Paranthodon africanus*, *Stegosaurus* (*Wuerhosaurus*) *homheni*, *Stegosaurus* (*Hesperosaurus*) *mjosi*, *Stegosaurus stenops* and *Tuojiangosaurus multispinus*): this compares with the worldwide total of over 1,000 other dinosaur species that lived during the 'Age of Dinosaurs', which spread over the Triassic, Jurassic and Cretaceous periods (which together make up the Mesozoic Era, which lasted from 252 to 66 million years ago). Moreover, all known stegosaurs lived during the Middle Jurassic to the earliest Cretaceous (from around 168 to 133 million years ago), only a fraction of the total time span occupied by dinosaurs. The very earliest dinosaurs lived around

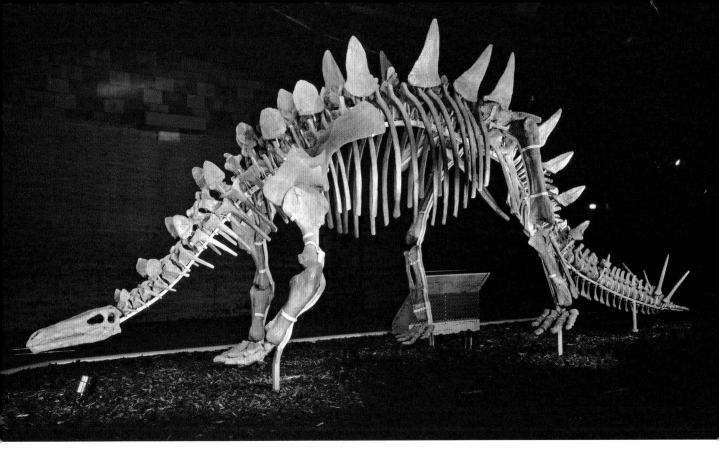

235 million years in the Late Triassic period – so dinosaurs had roamed the Earth for nearly 80 million years before the first stegosaur remains appear in the fossil record. Stegosaurs also became extinct long before the massive meteorite impact at the end of the Cretaceous Period. Finally, although other dinosaur groups inhabited all parts of the world during the Mesozoic Era, stegosaurs lived mainly in the northern continents of Asia, North America and Europe, reaching only Africa in the south. As a result, stegosaurs can in some ways be viewed as an unsuccessful experiment in how to be a different type of dinosaur: for example, they never became as widespread or common as the long-necked sauropods (*Diplodocus* and its relatives). However, despite this, their bizarre appearance and unusual features mean that they can tell us much about the limits of dinosaur evolution and biology.

**above** Stegosaurs, such as this *Tuojiangosaurus multispinus* from China, had a limited distribution in time and space, but a totally unique and easily recognizable body plan.

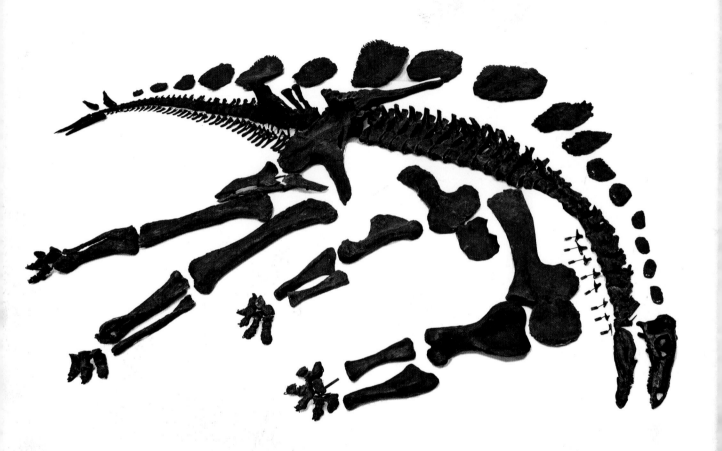

CHAPTER THREE

# A STEGOSAUR CALLED SOPHIE

**BOB SIMON'S FIELD CREW** worked full-time on the new *Stegosaurus* site for two weeks in late July 2004, painstakingly removing much of the rock overlying the find. They exposed around 80 percent of the skeleton and Bob recalled that, "This was an amazing experience, as with every piece of rock removed another bone would appear and we followed the vertebral column back into the rock wall [of the quarry] until we could go no further". Unfortunately, many of Bob's volunteer diggers had to leave the site at the end of July to return to their jobs and lives elsewhere, so work at the quarry ground to a halt. Many of the exposed bones were fragile, soft, easily broken and therefore difficult to remove from the ground. To avoid damaging the skeleton, Bob coated the outside of each bone with preservative chemicals, which helped to strengthen and hold them together. Rather than try to remove the skeleton on his own, which could have endangered the fragile bones, Bob considered closing the quarry for the rest of the year. This would have involved covering the site with loose soil and plastic sheeting to protect it from the winter weather and digging channels around the quarry to allow rain and snowmelt to flow away from the skeleton. The crew could then return the following year to complete the work that they had started. This practice is fairly commonplace when excavating dinosaur fossils, as it's not always possible to carefully and safely remove all of the bones from a large quarry in the limited time available during an annual field season.

Other fieldwork crews were in the same corner of Wyoming that summer, working on their own digs. One of these crews, led by Kirby Siber, was known to have extensive experience of excavating difficult dinosaur specimens. Kirby is a Swiss palaeontologist who runs his own museum, the Sauriermuseum at Aathal, and has been excavating Morrison Formation dinosaurs for many years. He has filled the Sauriermuseum with an impressive collection of iconic North American

**previous spread**
*Stegosaurus* fossil skeleton laid out before being mounted.

left Preservative chemicals were spread over each of the bones as they were excavated. These chemicals soaked deep into the bone and made them harder and stronger.

dinosaurs, including a display that includes three original stegosaur skeletons. Kirby had arrived in Wyoming to work at another quarry with his crew, but found that it wasn't possible to dig at this site after all. Knowing of Kirby's expertise, Bob invited him over to see the new *Stegosaurus* quarry in order to get his advice.

On seeing the specimen in the ground Kirby made the immediate decision to work at the site and to help Bob remove the specimen from the quarry. Kirby's crew set about strengthening the skeleton by using additional chemical preservatives that soaked deep into the bones, hardening them further. These chemicals took a couple of days to dry, but left the bones in a more stable condition for later removal. After this, the crew started to expand the quarry, uncovering more of the skeleton and digging a trench around the entire site to make the excavation easier. After around 10 days of digging in the August heat, the crew succeeded in exposing the entire skeleton, reaching a point where the individual bones could start to be removed.

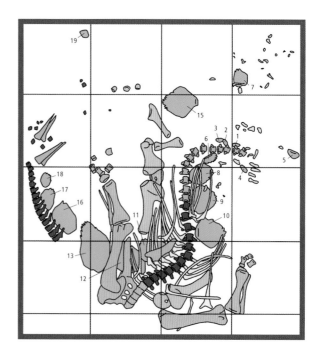

A detailed map was made of the quarry while the skeleton was still in the ground, recording the exact position of every bone. Many photographs were also taken of the bones before they were extracted and each bone was numbered for future reference. In order to get photographs of the whole quarry, the team photographer had to stand in the bucket of a bulldozer, which raised him around 5 metres (16 feet) above ground level in order to get a clear overview of the entire dig. This information is crucial for a number of reasons. Knowing the positions of the bones helps scientists to reconstruct the skeleton once back in the lab. In addition, the way in which the bones are distributed through the rock provides clues to how the skeleton was buried – whether it was by a river or in a mud-trap, for example, or if the skeleton was disturbed by predators – and this in turn can give insights into the animal's habitat and behaviour. It's also a good way of documenting how many bones are present and gives an instant visual snapshot of the completeness of the find.

skull
armour
forelimb
hind limb
cervical vertebrae
dorsal vertebrae
caudal vertebrae
ribs

Some dinosaur bones are strong enough to remove directly from the ground, and can simply be wrapped for transport. However, others are delicate and crack when first uncovered, a result of the geological forces acting on the bones over many millions of years, as well as the action of the weather on newly exposed fossils. In these cases, as with the bones of the new *Stegosaurus* skeleton, palaeontologists often leave the bones within a block of rock, which encases the bone (or group of bones) and protects it during the journey back to the laboratory.

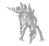

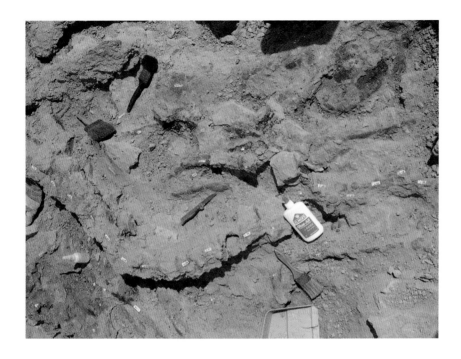

left Record keeping is important during a dig to prevent the loss of vital information. Each of the bones was numbered so that they could be recorded on the quarry map.

opposite This map shows the positions of the stegosaur's bones as they were found in the ground, with the colours representing different parts of the skeleton.

The bone-containing block can be protected by covering it with different kinds of material, but the most frequent method is to encase it in a plaster jacket, similar to the plaster casts that doctors use to support broken arms and legs in human patients. Surfaces with exposed bones are covered with a layer of paper or aluminium foil and then the whole block is wrapped in strips of sackcloth soaked with thick, wet plaster. Once the plaster dries it provides a very hard, tough coating that protects the bones while they are transported back to the lab. Bob, Kirby and the team removed the most fragile *Stegosaurus* bones first and encased each of these in their own plaster jackets. They then set about removing larger groups of bones together in larger jackets, using the natural gaps between the bones to divide the complex skeleton into separate jackets of varied size. The largest single plaster jacket was constructed around a huge block containing the chest area, which consisted of many ribs, vertebrae and some of the larger back plates. As

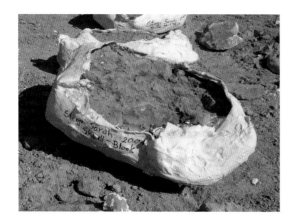 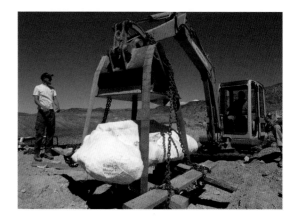

many of these bones overlapped and were in close contact it was not possible to divide this section into smaller parts without damaging the bones. The enormous jacket that resulted from plaster coating this entire block had to be strengthened with planks of wood and lifted into the back of a truck using chains, straps and a bulldozer. It was estimated to weigh around 700 kilograms (110 stones), or around the same as 10 average-sized people! This back-breaking work enabled the team to remove the skeleton from the quarry by the end of their allocated time in the field. During their work in Wyoming, Bob, Kirby and the other members of the team had nicknamed the *Stegosaurus* skeleton 'Sarah', naming it after the landowner's daughter, and early mentions of the new skeleton in the press and in the scientific literature sometimes used this nickname.

Mapping the bones in the quarry had shown that most of the *Stegosaurus* skeleton had been preserved, including a complete skull, almost all of the backbone and ribs, most of the bones of the shoulders and hips, three of the four limbs and an almost complete set of back plates and tail spikes. These areas of the skeleton

**above left and above** Field jackets made from plaster and sackcloth are immensely strong and are used to protect fragile fossils on their journey back to the laboratory.

**opposite** Sophie is one of the best preserved stegosaur specimens in the world: it is very unusual to find any armoured dinosaur skeleton that is so complete.

Mapping the bones in the quarry had shown that most of the *Stegosaurus* skeleton had been preserved

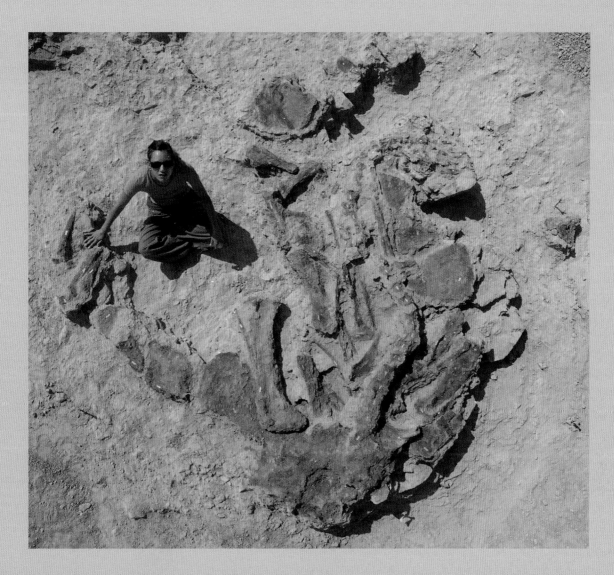

had been overlain by a hard sandstone layer that had helped preserve the bones from erosion, so these parts of the *Stegosaurus* were in good condition. However, those areas of the skeleton that had been covered by softer sediments did not fare as well: for example, the vertebrae from the base of the tail could be seen in the quarry as the team uncovered the skeleton, but the bones had been so badly weathered that they crumbled away before they could be collected. Nevertheless, only a few major body parts were missing: the left foreleg, part of the pelvis, one back plate, and many of the tiny bones of the hands and feet. It's likely that at least some of these missing bones may have been destroyed before the skeleton was originally buried or that some were weathered away by the erosion that was gradually eating away at the hill containing the specimen.

Three weeks after the arrival of Kirby's team, the plaster jackets containing the *Stegosaurus* were ready to leave the quarry. They were loaded on to trucks and driven to the airport for the long international flight to Switzerland. On arrival, they were taken to the Sauriermuseum, where Kirby and his team began the long and difficult process of opening the jackets, removing the bones from the surrounding sandstone, and strengthening the bones further to ensure their long-term survival. This work, called 'preparation', requires use of specialist tools and chemicals, steady hands, sharp eyes and lots of patience. Most of the preparation was carried out by Kirby's oldest daughter, Yolanda Schiker-Siber, who led a small team that finally released the bones from the rock. On arrival in the museum, the plaster jackets were opened up with chisels and saws to reveal their contents. Once the jackets were opened, a variety of hand tools, including small knives, scrapers and pneumatic pens (similar to the small drills used by dentists), were used to start removing the rock from around the bone. This is a painstaking job, as fossil bones are often softer than the rock in which they are encased and can

**left** This block of rock contains some of the skull bones. Each bone is still partly embedded in rock, which was slowly and carefully removed over a period of many weeks.

be easily damaged, which means that the rock has to be removed slowly in small amounts, sometimes a grain at a time. Once Yolanda's team had removed most of the rock, a tool called an air abrasive machine was used to provide a final clean. The air abrasive machine produces a rapid flow of compressed air, which is used to fire a stream of fine abrasive powder over the fossil at high speed. The fast-moving powder scours the remaining rock from the bone surface, revealing its fine detail. After the last grains of rock were removed, the team then filled small breaks, gaps and cracks within the bones with resin or putty to strength them and reduce the risk of future breakage. Finally, each bone was immersed in liquid adhesives, which soaked deep into the bone. This process made them tough enough to withstand handling and display. In total, it took Yolanda's team 18 months to finish cleaning the rock from the bones and to strengthen them, but at last the bones were ready for display and study.

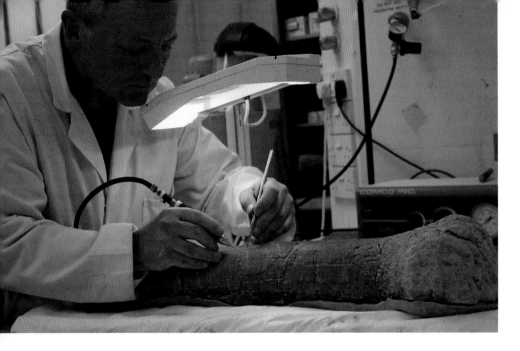

left A museum technician uses a variety of specialist tools to carefully remove all remaining rock from the bones.

The team in the Sauriermuseum also made several replica bones to replace parts of the skeleton that had not been preserved, such as the bones of the left forelimb and several of the bones in the tail. The shapes of these replica bones were modelled on those of other *Stegosaurus* specimens, but with their sizes adjusted to reflect the size and proportions of the new skeleton.

Following preparation, it was decided to make moulds of every single bone so that these could be used to make exact replicas of the entire skeleton. This work was carried out by another group of commercial fossil hunters, the Black Hills Institute. This business, based in South Dakota, USA, excavates dinosaur skeletons and other fossils for sale to museums and private collectors, and makes replicas for sale. So, in February 2007, 'Sarah' made another trip across the Atlantic, this time back to the USA for the moulding and casting to be carried out. Once completed, a replica was sent back to the Sauriermuseum, where it was put on public display in 2008, alongside several other *Stegosaurus* individuals in their exhibition halls. In addition to this, in 2015, a replica set of back plates from 'Sarah' was placed on display in the University of Manchester, UK. It is likely that

other museums will also acquire replicas of this beautiful skeleton as they update and modify their dinosaur displays.

As the *Stegosaurus* had been discovered on privately owned ranch land, it was the legal property of the rancher, who made the decision to sell the skeleton, with the hope that it would end up on display in a public museum. Once the preparation and casting work was completed, a sales proposal was put together and circulated to individuals and museums that might be interested in purchasing such a skeleton.

In January 2012, my colleagues Tim Ewin, Martin Munt, David Ward and I were representing the Natural History Museum at the Tucson Rock and Mineral Fair. This is an annual gathering in the small city of Tucson, Arizona, which is internationally famous as a major marketplace for rocks, minerals and fossils. Collectors and museum curators from all over the world visit the fair, which spreads out through the entire city, looking for new and unusual specimens or specular display objects. Among the stalls brimming with fossils of bizarre spiny Moroccan trilobites and gem-like Canadian ammonites, we spotted an impressive replica of a complete *Stegosaurus* skeleton on the stage in the main salesroom. We decided to go and chat with the owners of the replica, the Black Hills Institute, to ask them more about it. During the course of our discussion, we were surprised to discover that it was a replica of a single almost complete specimen, which had been nicknamed 'Sarah', and that the original skeleton was available for purchase. With a few more questions, we established who owned the specimen, where it was from, and, critically, how much the owners wanted to sell it for. The potential of the new *Stegosaurus* for the Natural History Museum was immediately obvious to all of us, as it could not only provide an amazing public dinosaur display, but also had incredible potential for new scientific work and as an object to encourage close engagement between the public and the natural world. During the rest of our short

stay in Tucson, we revisited the replica several more times and began to hatch a plan for trying to secure the original skeleton for the museum back in London.

On our return to the Natural History Museum, we showed pictures of the skeleton to our senior colleagues, and all agreed that purchasing the specimen would represent a fantastic opportunity. I was encouraged to find out more about the specimen and another contact of the owner, Raimund Albersdoefer, provided extra information about the discovery and the completeness of the skeleton. However, although all at the museum agreed it was a great specimen there was one major stumbling block – money. Complete dinosaur skeletons are expensive, and the museum's regular budget was unable to meet the cost of the skeleton.

However, luck was on our side: at the same time that we were discussing how to fund the purchase Jeremy Herrmann was elected Chair of the Development Trust of the Museum. Jeremy wished to help the museum advance some of its larger-scale projects and, after a pitch from the fundraising team at the museum, Jeremy chose the purchase of the *Stegosaurus* as the lead project for this new role. Leading 69 other donors, Jeremy raised the funds for the purchase and for some of the additional work that needed to be done with the skeleton before it went on public display. With his financial backing we were able to approach the owners and confirm that we were interested in buying the skeleton.

Before making the purchase, we needed to be sure that the real skeleton was really as good as the replica and the photographs we'd seen. At this time, most of the skeleton was in Salt Lake City, Utah, where it was being stored temporarily and where the frame for the skeleton was being built. So, in October 2013, Martin Munt and I were dispatched to Utah for a hectic two-day trip to assess the completeness and condition of the specimen. On arrival at the facility, Martin and I were stunned

to see the skeleton laid out carefully on the floor of the workshop, enabling us to examine every bone in detail. We quickly established that the skeleton was largely complete and well preserved and excitedly headed back to London to report on what we had seen. A few days later, I had to make a separate day trip to the Sauriermuseum in order to see the skull, which had been stored there while Kirby and his team had been making replicas of each delicate bone. It took me some days to remember which time zone I was in on returning to London! These trips allowed us to confirm the quality and authenticity of the skeleton and Martin and I recommended that the purchase go ahead. Following this a decision was made quickly, not least because we had been told another museum might be interested in making a rival bid. Taking rapid action, Sir Michael Dixon, the museum's Director, picked up the telephone and called Raimund to tell him we wanted to buy the skeleton. A few hours later, we had our answer – the Natural History Museum was now the proud owner of a new *Stegosaurus* skeleton, and not just any *Stegosaurus*, but the best-preserved skeleton of that dinosaur species ever found.

In order to recognize the invaluable help of Jeremy Herrmann in securing the *Stegosaurus* for the Natural History Museum, we decided to rechristen the specimen. From now on, the skeleton's nickname would not be 'Sarah', but 'Sophie' – named in honour of Mr Herrmann's oldest daughter, a huge fan of *Stegosaurus* and a frequent visitor to the museum.

A decision was taken to keep the purchase secret until the museum was ready to put Sophie the *Stegosaurus* on public display. This was for two reasons: to allow adequate time to properly plan the new exhibition and to permit scientific research on the specimen while all of the bones were unmounted and easily available, as they would be much harder to access for detailed studies when mounted on their frame for display. The skeleton was flown over from the USA in December 2013,

**overleaf** Paul Barrett sitting with Sophie the *Stegosaurus* during his trip to Salt Lake City in 2013.

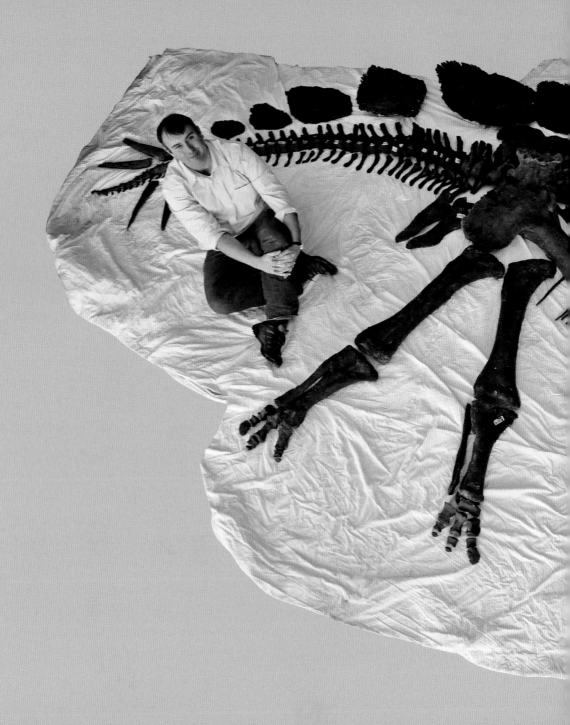

STEGOSAURUS

50

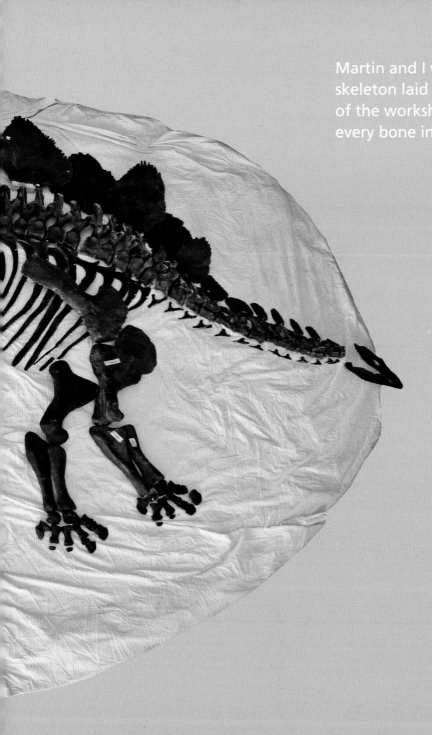

Martin and I were stunned to see the skeleton laid out carefully on the floor of the workshop, enabling us to examine every bone in detail

STEGOSAURUS

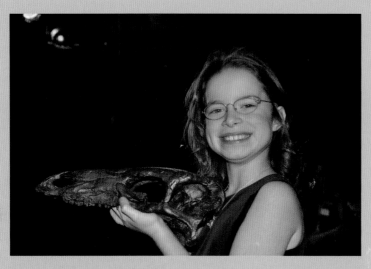

**WHEN I FOUND OUT** that for my 10th birthday my Dad was going to name a dinosaur after me, I was shocked but very excited. Dinosaurs have always presented me with an afternoon of documentary and hot chocolate, along with a massive interest and an unquenchable thirst for knowledge. Sophie the *Stegosaurus* provided me the chance to fully satisfy that thirst and spend some time with some truly amazing people. At 150,000,000 years old, it is like having a plated, thagomizered, sister! I have had some truly unforgettable experiences and will smile at the thought of all the research advances that Sophie has brought about. I will cherish the sight of my twin sister every time I go to the incredible place that is the Natural History Museum in London!

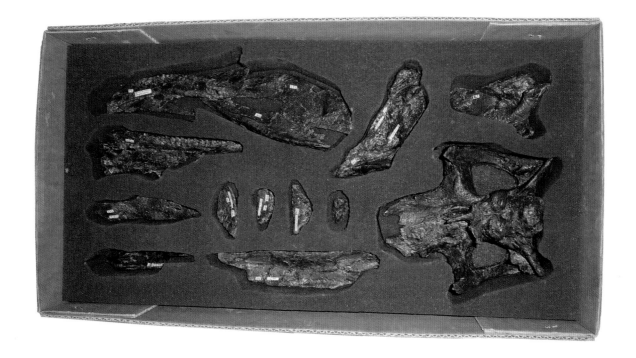

above Sophie's fragile skull bones were carefully packed for their transport to the Natural History Museum.

arriving on a cold, dark and misty afternoon just before the museum's staff left on their Christmas holidays. Sophie arrived in several huge crates, each of which was padded with foam to prevent the bones from being damaged during transport. A team of curators carefully opened the crates and began the task of unwrapping the bones and checking them, placing them into storage over the Christmas period. Around the same time, Raimund Albersdoerfer visited the museum carrying even more precious cargo: the fragile skull bones, which he brought over from Switzerland in three small padded containers, each of which was roughly the size of a large shoebox. As the bones were unpacked, everything was accounted for and we were relieved to see that all of the bones had survived the journey to London unbroken and in excellent condition. Sophie's skeleton had been reunited again at last: the best possible Christmas present for the museum's palaeontologists!

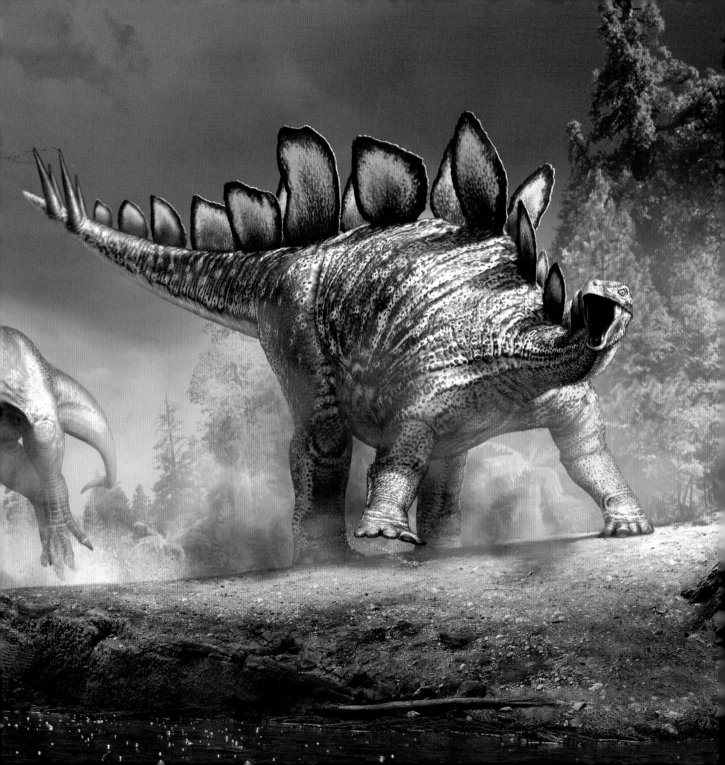

CHAPTER FOUR

# STEGOSAUR LIFESTYLES

**STEGOSAURS WERE** very distinctive dinosaurs, and all members of the group share the same overall body plan. But what do we actually know about the biology and lifestyle of stegosaurs? By dinosaur standards they were medium-sized animals, with the smallest members of the group, such as *Huayangosaurus*, reaching up to 4.5 metres (15 feet) in length, while the very largest *Stegosaurus* individuals attained a maximum adult size of 9 metres (just under 30 feet). Stegosaur heads were very small in comparison with the rest of the body, almost absurdly so, as at first glance it is difficult to imagine how this animal was able to take in enough food to fuel the huge, barrel-shaped body. The neck was surprisingly long and slender, but the chest and gut regions were very expanded, with the ribcage flared outwards. In side view, the backbone was curved downwards, so that the head and neck were close to the ground, while the back was strongly arched, reaching its highest point at the hips, with the hips much higher than the shoulders. Stegosaurs walked on all fours, but their front legs were much shorter than their hind legs, so that the chest was quite close to the ground. All four legs were strong and robust. The front legs were slightly flexed and ended in five-fingered hands, whereas the hind legs were held straight beneath the body like pillars and ended in three-toed feet. Looking down on a stegosaur from above, the slenderness of the head and neck contrasts strongly with the expansion of the rest of the body, especially the hip region, which is much wider than anywhere else. Stegosaurs all have a long, powerful tail that is almost the same length as the rest of the body combined. Finally, all members of the group are characterized by the presence of bony armour plates or spines that extend along the back of the body in two parallel rows. The skeleton, including all of the individual bones that make of the skull and lower jaw, as well as the armour plates and spines, consists of around 340 bones. Different species of

**previous spread** An artist's reconstruction of *Stegosaurus* in the Late Jurassic.

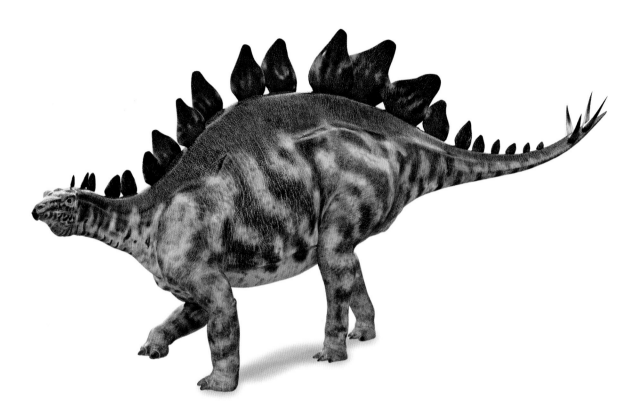

**above** One of the defining features of stegosaurs is the double row of armour along the back. This armour can consist of plates, spines or both plates and spines.

stegosaur sometimes have a more or fewer than this number depending on the length of the backbone and the number of plates and spines.

Although we now know that many meat-eating dinosaurs were feathered, there is no evidence that any stegosaurs had feathers or feather-like structures growing from the skin. However, some *Stegosaurus* and *Gigantspinosaurus* skeletons do have skin impressions preserved alongside parts of their bodies. These fossils show that stegosaur skin was scaly and that the scales were large and many sided, similar in appearance to the scales of many living reptiles, but larger. Unfortunately, we have no direct evidence on stegosaur colour patterns, so artists have had to make guesses about their appearance. Many older reconstructions usually depict stegosaurs in dull greys, greens and browns, like most large living animals today, such as elephants and rhinos, but more recent artworks have used

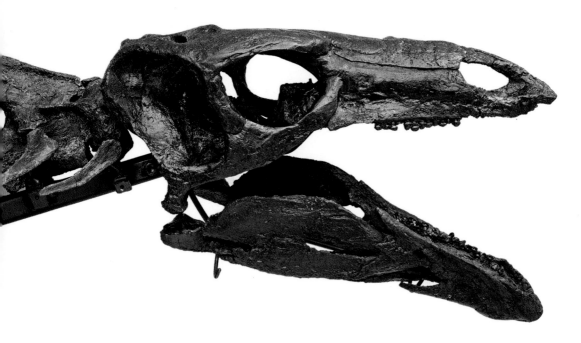

above The long, narrow skull of stegosaurs had jaws that were tipped with a horny beak for cutting vegetation.

brighter bolder colours and patterns. Sadly, as evidence for colour rarely fossilizes, we may never know for sure.

Many features of the stegosaur skeleton indicate that these animals were herbivores, which lived solely on a diet of leaves and shoots. Perhaps the clearest indication of this comes from their teeth, which lack the fine steak knife-like serrations and curved tip typically seen in flesh-eaters. Instead, stegosaur teeth are very small, flattened from side-to-side and have a blunt, triangular outline. The sides of the teeth bear a few grooves and ridges and their edges are wrinkled, with large cusps. These teeth are very similar to those of living herbivorous reptiles, such as iguanas, and were ideally suited to the grasping and ripping of soft vegetation. Other features of the skull also indicate a vegetarian diet. The tips of the upper and lower jaws were covered in a sharp horny beak made from keratin, the same substance that makes up hair and fingernails, and this was used to pluck leaves and small branches from plants. Most stegosaurs would also have had cheeks spanning the gap between the upper and lower jaw, which would have

helped keep food in the mouth while swallowing. Large curved bones in the throat region also show that stegosaurs had powerful tongues for moving food around in their mouths. The jaws were not adapted for chewing, but seem to have been used mainly for biting through plants and gathering mouthfuls of food, which were then swallowed whole. The swallowed food would then enter the enormous stomach and intestines, which took up most of the space in the barrel-shaped body, where it would be slowly digested. A really large *Stegosaurus* may have had to eat 50 kg of plant food per day or more in order to stay alive. Unfortunately, there is no direct evidence on stegosaur diet, as no fossilized gut contents or dung have yet been found for these animals. However, it seems likely that they were feeding on the common low-growing plants whose fossils are also found in the Morrison Formation: ferns, horsetails and cycads.

**above** Stegosaur teeth are tiny in comparison to the overall size of the skull. They have coarse serrations for puncturing leaves and stems.

A popular 'fact' about *Stegosaurus* is that it is often said to have had two brains. A brain in its head, as expected, and a second 'brain' in the hip region. This idea goes back to some of the earliest work on *Stegosaurus*, when Marsh noticed that the canal carrying the spinal cord through the hips was very large in this animal. Due to its large size – larger than the brain cavity within the skull – he reasoned that this canal was filled with nerves and that this second 'hip brain' might be useful in helping coordinate the movements of the hind legs and tail. However, this idea has now been rejected by scientists. Although the spinal cord canal in the hip region is large, comparisons with living animals suggest that it wouldn't have been packed with nerves. Many living birds show a similarly expanded canal in their hips, but instead of being filled with nerves it is filled

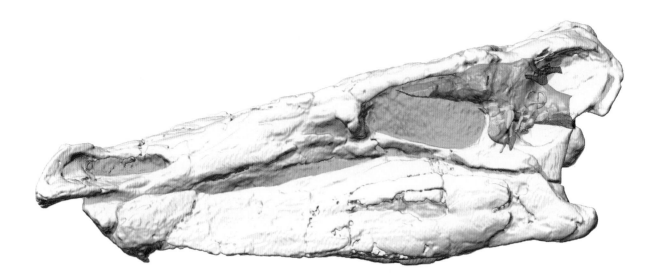

with a substance called glycogen, forming a structure known as a glycogen body that lies alongside the spinal cord. Glycogen is a sugar-based substance used by animals and plants to store energy within their bodies. So the expanded spinal cord canal of *Stegosaurus* is more likely to have housed an energy reserve than an additional 'brain'.

Another frequently quoted 'fact' is that *Stegosaurus* had a brain the size of a walnut. Although this isn't true – the brain was quite a bit larger than a walnut and closer in size to a large plum or satsuma – it has to be admitted that *Stegosaurus* and its relatives were not particularly brainy dinosaurs. One way of determining a species' relative level of intelligence is to compare the weight of the brain with the body weight. Usually, there is a good relationship between these two measurements, and it's often possible to predict the brain size using body weight. However, in particularly smart animals, such as humans and dolphins, the brain is much larger than would be expected from body weight alone. Conversely, if the brain is much smaller than might be expected from an animal's body weight, we might deduce that the animal was not particularly intelligent. Sadly, the small brain of *Stegosaurus*, in combination with its very large body size, means it falls into the latter category.

**above** This image shows the position of the brain (in purple) and inner ear (in pink) in *Stegosaurus*, based on Computed Tomography (CT) scanning of the Smithsonian's *Stegosaurus* skull.

A handful of scientists have suggested that stegosaurs walked bipedally (on their hind legs only), but the majority of palaeontologists have rejected this idea and consider stegosaurs as fully quadrupedal animals (walking on all four legs). The main evidence for this comes from the general proportions of the skeleton, which do not match those of a bipedal dinosaur, and also from *Stegosaurus* trackways, which always include the prints from both the hands and the feet, showing they were all used for weight support while walking. *Stegosaurus* trackways are very distinctive thanks to the differing number of fingers (five) and toes (three) on the prints, a combination that is unique among quadrupedal dinosaurs. By measuring the lengths of the individual footprints and of the distance between footprints in a trackway, it is possible to calculate the walking speed of the animal that made the tracks. These measurements suggest top walking speeds of around 6–7 kilometres per hour (around 4 miles per hour) for *Stegosaurus* and that stegosaurs were not capable of anything more than a brisk walk. These kinds of speeds are comparable to those of a walking elephant, although elephants are known to be able to run for up to 15 kilometres per hour (9 miles per hour) over short distances. This work on trackways has also been confirmed using computer models of *Kentrosaurus* skeletons, which show that the hind legs could not have been moved back and forth for distances great enough to support rapid movements. Moreover, the difference in length between their forelimbs and hind

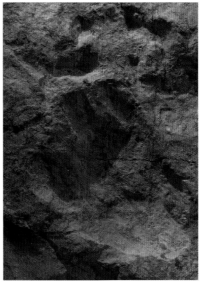

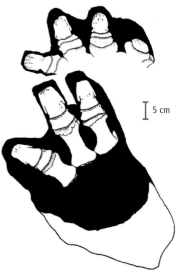

**above** Stegosaurs had a distinctive pattern of hand and toe prints, with five fingers and three toes, which differs from that of other dinosaurs.

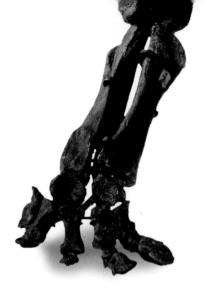
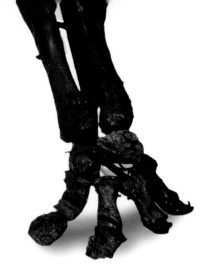

limbs, the quadrupedal stance and the short length of the lower leg bones (shins) relative to thigh length also suggest that stegosaurs would have been very slow moving and not particularly athletic. Recently, it was suggested that stegosaurs might have been able to swim, based on some unusual trackways that showed drag marks from the toes, which might have been made by a floating animal pushing against a riverbed. However, although it is possible that stegosaurs went into rivers and lakes from time to time, in order to bathe or simply to cross, it seems unlikely that this was a common behaviour.

Although stegosaurs were quadrupeds when walking, this doesn't mean that they were confined to being on all fours all of the time. Their centre of mass lies under the hip, and the backbones making up the hip region have long spines that would have anchored powerful back muscles. These features, in combination with the relatively short front legs and much longer hind legs, all suggest that stegosaurs might have been able to pivot upward around their hips, rearing up so that the front of the body could be raised from the ground for short periods of time, a possibility confirmed by computer modelling of *Kentrosaurus* skeletons by German palaeontologist Heinrich Mallison. This rearing behaviour might have been important for several reasons. Perhaps most importantly, it would have increased feeding range, allowing the stegosaur to access plants that it wouldn't be able to

**above** *Stegosaurus* forelimbs were strong, stout and adapted for bearing the animal's weight. Each finger ended in a hoof-like toenail.

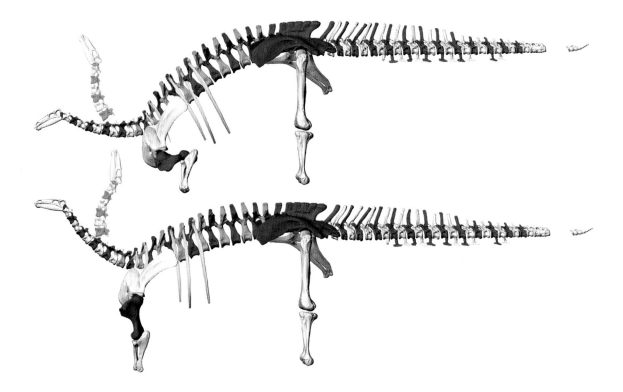

**above** Detailed computer models of this *Kentrosaurus* skeleton allow scientists to experiment with changes in posture and stance, such as testing rearing behaviour, without endangering the original bones.

reach while in its usual quadrupedal pose. By rearing on its hind legs a stegosaur could more than double the height its mouth could reach above ground level. Rearing might also have been important in intimidating predators, by making the stegosaur appear even larger than it actually was. Finally, it is possible that the ability to balance on hind legs only may also have been useful in mating.

Very little is known about stegosaur reproduction: stegosaur nests and eggs have not yet been found. It's also difficult to imagine how stegosaurs mated, given the spines and plates that line their backs and tails (the usual answer given to this question by palaeontologists is "Carefully!"). In addition, only two small stegosaur specimens are known: most of the other material in museum collections belongs to individuals that were adults or subadults when they died. The two smallest stegosaur specimens are both from the Morrison Formation and are thought to

be *Stegosaurus* juveniles that would have been 1.5 and 2.5 metres (5 and 8 feet) in length. These juveniles differ from the adults in a number of ways, including the shapes of their arm and leg bones and in the ways the hipbones are attached to each other. Most interestingly, neither of these small skeletons includes any of the characteristic armour plates expected for *Stegosaurus* (although the tail spines are present). This might suggest that the plates only developed later in life, although it is also possible that they were present originally and lost at some stage of the fossilization process. A little more is known about stegosaur growth thanks to a surprising source: the detailed microscopic structure of their bones. As bones grow, they lay down new bone tissue in rings that surround the older bone. These rings can be thought of as similar to tree rings and, like tree rings, are also thought to appear on a yearly basis. These growth rings are visible if the bones are sliced open and cut into thin slices that can be viewed under the microscope. Counting the rings and looking at the spacing between them can provide information on the age of the animal when it died and how quickly it grew in each year of its life. Only a few *Stegosaurus* individuals have been examined in this way so far, but it appears that baby stegosaurs grew quite quickly until they reached adolescence, although not as fast as species in other dinosaur groups. Unfortunately, there's limited evidence for the lifespan of stegosaurs, but they appear to have reached adulthood at around 8–12 years.

It's not clear whether stegosaurs were sociable animals that lived in groups, or whether they were more solitary by nature. Most finds of these animals in the USA, Europe and China have usually been of single individuals and their remains have not generally been found in groups (although they are sometimes mixed with those of other dinosaurs). This has led to the idea that for most of their lives stegosaurs probably wandered alone. However, in reality the picture is more

complicated. A few stegosaur trackways seem to show several individuals walking together, and some new quarries in the USA have been found to contain the remains of several *Stegosaurus* individuals. However, in many of these cases it's not clear if the animals were genuinely in the same place at the same time or whether the different animals present in these sites arrived there at different times. Whether stegosaurs were sociable to some degree or not, there is no evidence whatsoever that they lived in large herds (in contrast to some other dinosaurs, such as hadrosaurs). The general rarity of stegosaur skeletons suggests that they were uncommon dinosaurs, even at their peak.

The most conspicuous features of stegosaurs are the arrays of plates and spines that extend along their backs. The number and position of plates and spines vary between species and are two of the most important and obvious ways in which we distinguish stegosaur species from each other. However, it has to be remembered that we don't have many complete stegosaur skeletons to work with, so it's possible that future discoveries will provide surprising new information on the exact plate/spine array in each stegosaur species. Indeed, we can only be confident about the complete set of plates/spines in *Stegosaurus*: for reasons of incompleteness there are still some question marks over the exact numbers of plates and spines in all other stegosaurs, even *Kentrosaurus* and *Huayangosaurus*, which are both known from reasonable amounts of material. Spines and plates are made from bone and in life would have been covered with a layer of keratin – the same fingernail-like substance that makes up its horny beak. They did not attach to the rest of the skeleton directly, but would have been embedded deep within the skin of the animal. In all stegosaurs, the plates and spines are arranged in two parallel rows that extend along the neck, back and tail. As a result, they are usually paired along the length of the body, with those on one side of the

animal mirroring those on the other side. *Stegosaurus* is an exception to this rule, however – although it has two rows of plates/spines, these rows are staggered and offset from each other, forming an overlapping arrangement of plates rather than two mirror-imaged rows. As far as we know, the tails of all stegosaurs were tipped with at least one pair of spines and sometimes two pairs. In addition to the plates and spines along the back, a few stegosaurs (*Gigantspinosaurus*, *Kentrosaurus* and *Loricatosaurus*) also have an extra pair of very large spines that stick outward and backward from the shoulder region. Finally, some, but not all, *Stegosaurus* individuals also have a set of very small, rounded pieces of bone, each 1 centimetre or less (up to a third of an inch) in diameter, embedded in the skin under the throat (these are missing in Sophie).

The functions of the plates and spines have been debated heavily and many different ideas have been proposed to account for their varying shapes, sizes and distributions over the body surface. It's worth noting that the spines and plates might have been able to perform several different tasks at the same time, so accepting one or another of these functions does not necessarily rule out any of the other ideas.

One of the first theories to be proposed was that these plates and spines served an important defensive function, acting as weapons and armour that might have deterred attacks from large carnivorous dinosaurs. This seems plausible, especially for those stegosaurs like *Kentrosaurus* whose backs were lined with stout pointed spines, and whose shoulders were also armed with long curved

spines. Such spines would have made it harder for carnivorous dinosaurs to attack from the side or above and may also have served as weapons as the stegosaur moved around, butting against its attacker. The spines lining the tail of some species, and the set of spines at the end of the tail seen in all stegosaurs, are even easier to envisage as defensive structures or weapons. Stegosaur tails were very powerful, with huge muscles at their base that were capable of exerting mighty forces. Moreover, computer modelling of the joints within the tail by Heinrich Mallison showed that it was flexible and could be swung through a wide arc, enabling it to pick up impressive speed as it was swung from side to side. Calculations based on the speed and weight of the tail suggest that the tail spines could have been used to deliver devastating blows to an attacker. These blows would have been more than capable of tearing through flesh and breaking bone. Indeed, one *Allosaurus* hipbone shows a large oval-shaped puncture would that was probably made by the impact of a *Stegosaurus* tail spine.

The role of the plates as defensive structures is much less certain. The first palaeontologists to study *Stegosaurus* assumed that the large plates must have been armour used for defending the back. A few scientists even suggested that the plates could be raised and lowered to protect the animal's vulnerable sides. However, we now know that the plates could not be moved as they were deeply embedded in the skin, were not jointed with the underlying backbone, and were not attached to any muscles that could have been used to move them around. Although the plates of *Stegosaurus* are very large – the largest, those over the hips, could reach around 1 metre (3.3 feet) in length – they are very thin. The plate base is quite thick and expanded, but the central part of the plate and the edges are only a few millimetres thick. Even when the animal was alive and the plates were covered by keratin, they would still have been rather flimsy structures.

**opposite** This computer model of the *Kentrosaurus* tail shows that it was very flexible and would have been an effective weapon.

**overleaf** *Stegosaurus* uses its impressive array of tail spikes to protect itself from the large and predatory theropod dinosaur *Ceratosaurus*, which also lived in Late Jurassic North America.

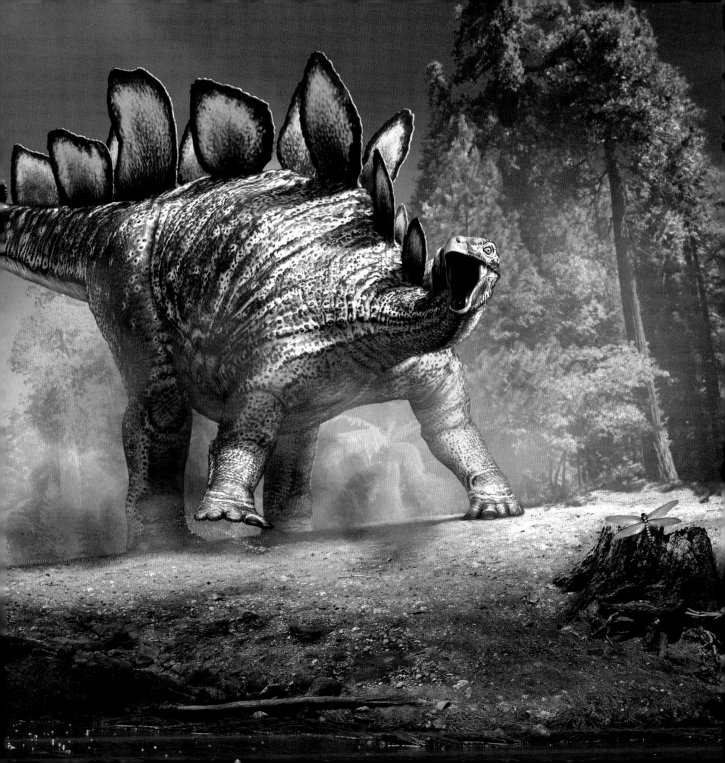

It seems unlikely that these thin plates would have been useful as armour, as many of the large predators that lived alongside *Stegosaurus*, such as *Allosaurus*, would have had strong jaws that were probably capable of snapping through such thin bone. Nevertheless, *Stegosaurus* is unusual among stegosaurs in having large diamond-shaped plates – the majority of stegosaurs have rows of spines along their backs instead.

Several other functions for stegosaur spines and plates, especially the huge plates of *Stegosaurus*, have also been proposed. As already mentioned, different stegosaur species have different numbers of plates and spines, and these have a variety of shapes and sizes. This has led to the suggestion that the exact arrangement of the plates/spines is a visual signal that allows stegosaurs to easily distinguish individuals of its own species from those others, even over a distance: a phenomenon that scientists term 'species recognition'. Species recognition is important in living animals in terms of finding mates and other members of their social groups. However, it's not clear if this was important for stegosaurs, as the fossil record shows that there is often only one stegosaur species living in one place at any time, so the need to distinguish between different species may not have been important.

Another possibility, favoured by many palaeontologists, is that the plates and spines were used for display. Many of the more spectacular features of living animals, such as horns and antlers, are used precisely for this purpose today. The sizes and shapes of these structures often reflect the strength, age and physical condition of their owners and can be used to show off these attributes to competitors, predators and potential mates. It's possible that stegosaurs did the same, using their spines and plates to display at each other in disputes over territory, to attract mates, or even as a defence mechanism to intimidate potential attackers.

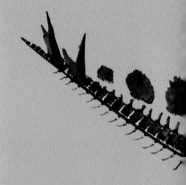

**right** Taken together, the back plates of *Stegosaurus* form a visually impressive signal that could have been for display. Other stegosaurs had different arrangements of plates and spines.

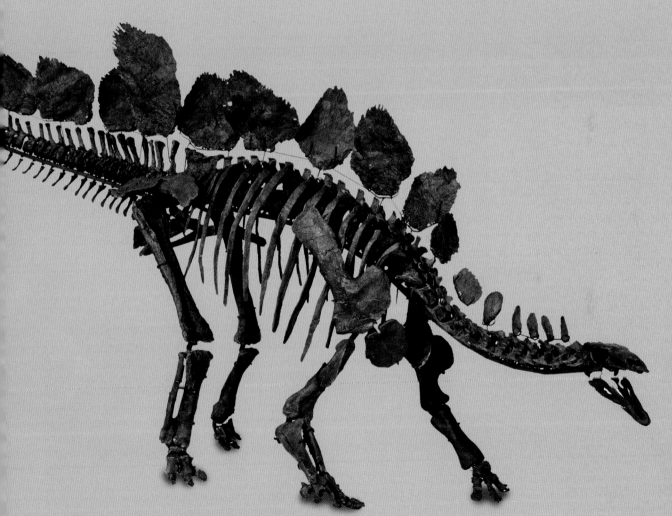

Even when the animal was alive and the plates were covered by keratin, they would still have been rather flimsy structures

Some scientists have taken this idea further by suggesting that the plates might have been brightly coloured to enhance their display potential, although we have no direct evidence for plate colour at present. It has also been suggested that plate size or shape might vary between male and female stegosaurs, providing an easy way of sexing their skeletons. This idea is intuitively appealing as many of the display structures in living animals are known to vary between males and females. However, there is no conclusive evidence to support this interesting idea at present.

A final proposal is that the expanded diamond-shaped plates of *Stegosaurus* may have played a significant role in another important biological function: temperature regulation. Mathematical models of plate size and shape suggest that, when taken collectively, *Stegosaurus* plates have such a large surface area that they might have been useful for gathering or losing heat. By turning sideways to the sun, they would maximize the surface area of the plates exposed, which may have been able to help them warm up their bodies. Conversely, facing away from the sun would reduce the area exposed and might have allowed cooling. In addition, the spacing between the plates would have enabled warm or cool air to circulate around them efficiently, as between the fins of a radiator. Each of the plates contains a fine internal network of small channels that probably housed a rich blood supply. This blood could have coursed through the thin plates and been warmed or cooled, depending on the conditions, before returning to the body. Scientists still debate whether this mechanism might have been important for *Stegosaurus*, but it's important to note that the spines of other stegosaur species would not have been able to contribute to temperature regulation in the same way, due to their much smaller surface area.

Everything we know about stegosaurs highlights just how unusual they were, even by dinosaur standards. Although their remains have been known for nearly

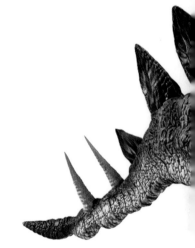

150 years, many aspects of their behaviour and biology remain mysterious, due to the lack of good, complete specimens. Their highly unusual and modified anatomy also confounds close comparisons with other living and extinct animals that might otherwise offer clues on their habits and lifestyles. The discovery of every new specimen has real potential to reveal previously unknown aspects of stegosaur ecology and evolution.

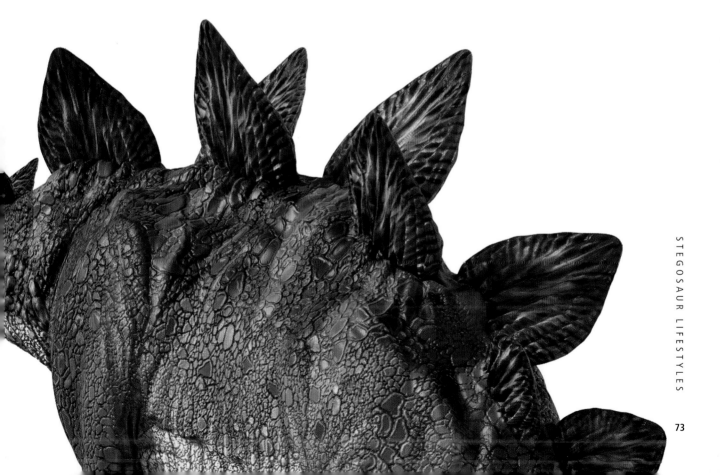

below It is possible that *Stegosaurus* plates were brightly coloured and may have been useful in attracting mates or intimidating rivals.

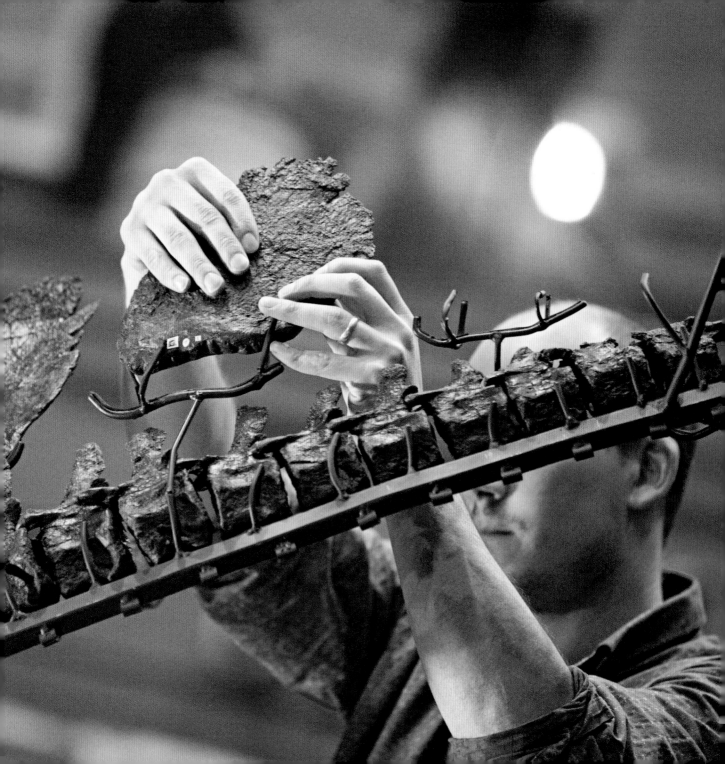

CHAPTER FIVE

# BUILDING A DINOSAUR DISPLAY

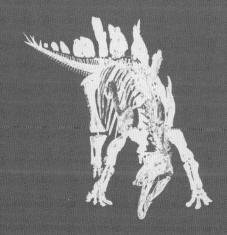

**THE ARRIVAL OF SOPHIE** at the Natural History Museum, London marked the beginning of a major project to design, build and install a new display that would allow visitors to see every part of Sophie's skeleton. It was decided to keep Sophie behind the scenes while this work took place, providing an opportunity to study the bones in detail before they were put on exhibition. Each of the bones required many careful measurements, photography and the taking of detailed notes to record their features, and it was much easier to carry out this work with the bones laid out in storage, where they could be examined from every angle and re-examined to describe them thoroughly. A large team of up to 40 museum specialists was assembled to tackle 'Project Sophie', with each team member contributing their own specialist skills. Some members of the team concentrated on the scientific description of the skeleton, while others were involved in cleaning and preparing the bones for display. Another group designed the plinth on which Sophie would stand and the lighting that would illuminate the display, as well dealing with adjustments to the frame on which the bones were mounted. Other team members concentrated on the information that would be provided with the exhibition and how it would be presented. Important information was needed from staff working in the museum galleries, who gave advice on how museum visitors interacted with displays and the rules and regulations surrounding these busy public spaces. Finally, the museum's press team was asked to work on the best ways of announcing the opening of the exhibition to the outside world. A project manager, Beca Jones, was appointed to oversee the whole enterprise, making sure that each part of the team was able to deliver their contribution on time. It was decided to do all of this work in secret, so that the completed exhibition could be unveiled as a surprise new addition to the museum's galleries, with a target opening date of December 2014. Given the levels of excitement within the museum, this became a hard secret to keep!

**opposite** A museum technician painstakingly cleans the bones prior to the unveiling of the new display.

**previous spread** A member of the team carefully inserting a tail plate into the new display mount.

A large team of up to 40 museum specialists was assembled to tackle 'Project Sophie'

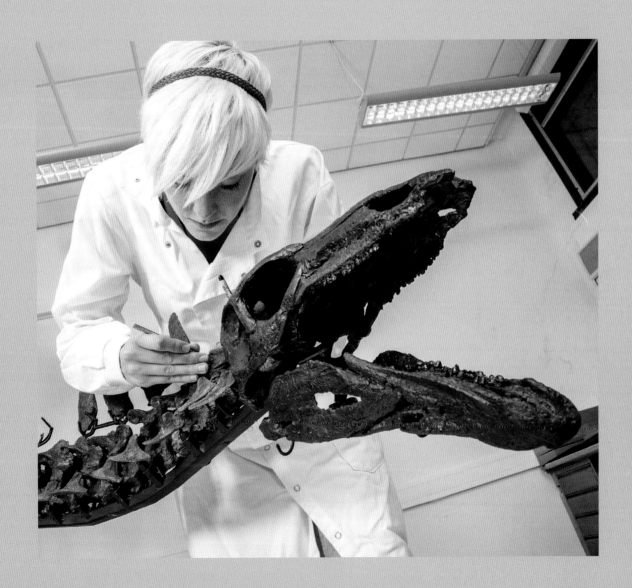

BUILDING A DINOSAUR DISPLAY

The team's first decision was an important one – where was the best home for Sophie within the museum? After all, the museum's dinosaur gallery was already full. Following many discussions, it was decided to put the new exhibit in the museum's Earth Hall, at the base of the escalator leading up into the Earth Galleries, close to the museum's Exhibition Road entrance. As a result, Sophie was given pride of place and would be the first object that many visitors would see as they entered the museum, providing a spectacular first impression. To make room for the new display, an older exhibit had to be taken away and its removal marked the first big challenge for the project team. During the summer of 2014, this whole area was sealed off to allow the work of removing the old exhibit to begin. This involved taking other specimens off of display and returning them to the museum's collections, as well as moving four large statues that had been standing in this area. Once the statues and display cases had been removed the area was re-opened, having been given a major makeover. Although these changes were noticed by everyone in the museum and by many regular visitors, the reason for these changes still remained a closely guarded secret.

Meanwhile, work began on the new exhibition itself. The frame that was to hold the skeleton had already been designed and built by Brock Sisson, the owner of a specialist company based in Salt Lake City, USA that prepares dinosaur skeletons for museum exhibitions. Sophie's skeleton had already been stored at the company's facility prior to its arrival at the Museum. As a result, Brock and his team were able to make all of the measurements they needed to build the frame while they had Sophie's bones available. It was decided to pose Sophie in the frame with the head turned to one side, one leg raised as though walking and with the end of the tail held up in the air. This represents an 'alert' posture, which is imagined as if Sophie was keeping a wary eye on a potential predator. The frame

above The frame for the skeleton is shown in place in the Earth Hall during the building of the exhibition. A small number of the larger bones have been attached.

is made of steel, painted black and cushioned with foam to protect the bone surfaces. Each of the bones is held in place by carefully positioned clips and bolts to prevent them from falling. The completed frame was shipped to the museum at the same time as the skeleton.

Choices had to be made on the shape and size of the plinth that would support the frame and skeleton, what it would be made of and how it would be lit. Exhibit designer Gemma Smith produced different styles of plinth by building computer-based and small-scale models of the skeleton and then envisioning how these designs would best fit within the Earth Hall. In addition to holding the skeleton, the plinth had to include spaces for the lights that would illuminate

**left** Each bone had to be carefully positioned within the frame. It took the team over four hours to mount the whole skeleton.

Sophie from below and for the information panels. It also had to be large enough to prevent inquisitive visitors from reaching over to touch the fragile skeleton, had to absorb vibration, and needed to include a rail, all in order to afford the specimen some protection. An oval design was chosen, including a pillar at the back to provide additional support for Sophie's upraised tail. The surfaces of the plinth were textured, recalling the layers of rock from which the skeleton had been excavated, and a light colour was selected to form a good contrast to Sophie's chocolate-brown bones. As the plinth was being constructed, the museum's engineering team, Steve Suttle and Joe Rodrigues, needed to make last-minute adjustments to the frame, ensuring that it could be attached to the plinth and adding a little more strength to the attachment points for each of the bones. A specialist external company was commissioned to design the lighting around the skeleton, in order to highlight each of the features in Sophie's skeleton.

Alongside work in the Earth Hall and on the building of the plinth, another part of the team was working on the information that would be presented alongside the skeleton. Information about Sophie would be included in several panels that would be mounted on the plinth and an information kiosk would be positioned on one of the balconies overlooking the specimen. Exhibition interpretation designer Jenny Wong was tasked with compiling the key facts about Sophie and with devising new ways in which to share this information with visitors, while graphic designer Marc Desmeules began to work on the visual appearance of the panels and kiosk. The information panels on the plinth were designed to be relatively small, so as not to detract from the skeleton or to cause congestion within the space around the exhibit. More detailed information was reserved for use in the kiosk, which included not only more text, but also movies relating to Sophie's discovery and several replicas of Sophie's bones, including the skull, a back plate and a tail spine. These replicas are exact copies of Sophie's original bones, created by using a laser scanner to capture the 3D details of the bones and then using these to make a model of the bones in a computer. This model can then be 3D printed in plastic at a very high level of detail. These computer models were made as part of the scientific work on the skeleton, and there are more details on this process in the next chapter. In addition to the information panels and kiosks within the Museum itself, Jenny and her colleague Lisa Hendry were also responsible for writing new pages for the Museum's website, detailing the new exhibition. During this period, Sally Weale and her team also

**above** The tip of the tail, and the impressive spikes on the end, are the highest point on the mounted skeleton.

spent a lot of time filming the scientific work on Sophie and other work on the project, as well as interviewing many members of the project team, in order to include all of this background information in movies that could be accessed from the information kiosk and that would also be posted on the museum's website.

While Sophie's skeleton was hidden behind the scenes, Lu Allington-Jones and Laura Fox from the Museum's conservation laboratory worked on each of the bones, documenting their condition and making sure that they were fully cleaned of packaging and casting materials and strong enough to go on exhibition. Lu and Laura made detailed notes and photographs of the skeleton, recording the state of its preservation so that any potential problems could be identified and repaired before it went on display. Their work also formed a permanent record of the state of the specimen, which can act as a useful comparison in case any future repairs are needed. Each of the bones also had to be labelled and numbered, and this job was completed by Sandra Chapman, the curator of the Museum's dinosaur collection.

In order to depict Sophie as a living animal, palaeoartist Robert Nicholls was commissioned to produce two new, original artworks for the exhibit that would show Sophie as a key member of the Morrison Formation ecosystem. One of these depicts a general Morrison ecosystem scene, with Sophie alongside a river, gazing at an *Allosaurus* feeding on another less fortunate *Stegosaurus*, while a *Diplodocus* walks through the dense undergrowth nearby. The other reconstruction shows Sophie in defensive mode, using the powerful tail to ward off the attack of an aggressive *Ceratosaurus*. In the latter image, Sophie is shown in the same pose as the mounted skeleton in the Earth Hall. In order to produce these artworks, which were painted electronically, Robert visited the museum to spend time looking in detail at the skeleton and its pose, taking measurements and researching the appearance of *Stegosaurus* to make the paintings as accurate and realistic as possible.

opposite This reconstruction of Sophie as a living animal was based on detailed research, not only on the skeleton, but also on the other animals and plants that lived alongside *Stegosaurus*.

All of these tasks continued in parallel throughout the spring, summer and autumn of 2014, as the date for the unveiling drew closer and closer. As the time drew nearer, the pace of work increased dramatically, with each team completing each of their individual tasks to meet the deadline. In November 2014 large wooden screens were erected at the base of the escalator in the Earth Hall, hiding the area

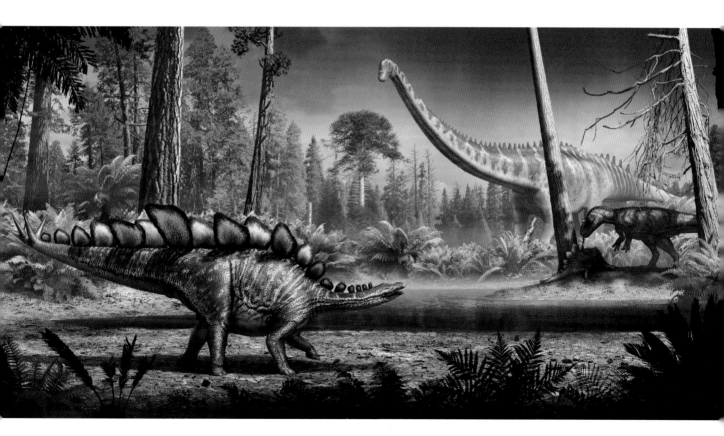

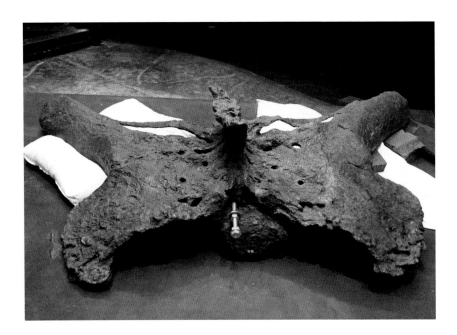

**left** The large pelvic block, containing Sophie's huge hip bones, is the heaviest piece of the skeleton and had to be placed in the frame first.

from view, so that the work of installing the display could begin. A second set of screens was also erected on the balcony overhead, to hide the area from view and also to allow the information kiosk to be built. First, the separate sections of the plinth were brought into the main Earth Hall space, assembled and fixed to the floor. Once the plinth was completed, the lights were placed in position and Sophie's frame attached to the plinth. The information panels and security rail were also installed at this point and work on the information kiosk completed. The work went smoothly, but each of these jobs took several days to complete: finally, the plinth and frame were ready for Sophie's arrival. On 1st December 2014, a team of Museum palaeontologists gathered to transport the bones from their storage area to the Earth Hall. As Sophie had already been in the Museum for nearly a year, and as the frame had also been available for all of that time, the team had been able to practise mounting all of the bones on the frame several times, while the skeleton was being studied behind the scenes. As a result, the team knew the challenge ahead of them,

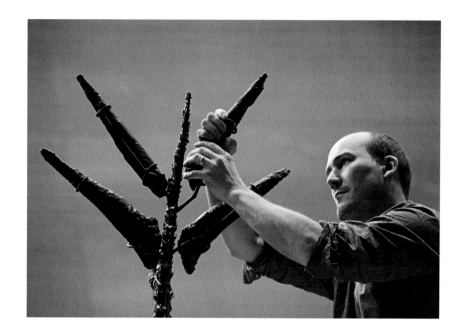

left After several hours of careful work, this tail spike was the final piece of the skeleton to be placed on the frame. Mission accomplished!

although the additional height of the plinth provided a new difficulty that hadn't been encountered during the practice mountings. Nevertheless, one by one each of the bones was placed in its correct position within the frame. The first to be added was the huge pelvic block, the largest individual part of the skeleton and the key to the rest of the mounting. Given the height of the plinth and the size of the block, this had to be moved into place with a small winch and crane, while several team members steadied it, guiding it into place. Once secure, the rest of the backbone and limb bones were relatively easy to put in position, with some members sorting and organizing the bones, while others clamped them in position on the plane. A small cherry-picker had to be used when adding the plates to the back and the smallest bones at the end of the tail. The last bone to be added was one of the tail spines: every bone in place and no accidents! Seeing the complete skeleton in its new home for the first time was an exciting moment for the team: the culmination of a full year of very hard, but fulfilling, work.

The next two days witnessed even more activity around the skeleton as final preparations were made for the official opening of the exhibition. On the morning of 3rd December 2014, members of the UK and international press were invited into the Museum to see Sophie, leading to newspaper articles, web articles and radio and TV interviews that would be broadcast all over the world. Later that day the area was cleared and made ready for a party that night, which was hosted in the Earth Hall by Mr Herrmann to thank the donors who'd made the project possible. Sir David Attenborough attended and spoke about the importance of Sophie and of museum collections in bringing the past to life. Then, on the morning of 4th December 2014, the screens were removed and the Museum opened its doors to the public. Finally, Sophie was no longer a secret. Sophie was quickly established as one of the museum's most iconic displays and could claim to be one of its most popular exhibits of all time. Crowds of visitors surround the skeleton every day, gazing in awe at Sophie's small box-like head, barrel-shaped body and impressive array of plates and spines. However, Sophie is not just an amazing display specimen. While the exhibition team carried out their work, the scientific team had been finding out many new and surprising things about the anatomy of *Stegosaurus*. Sophie's well-preserved and substantially complete skeleton was allowing them to delve into *Stegosaurus* biology in ways that had not been possible or attempted before …

right Sophie's skeleton provides a spectacular sight for visitors entering the Natural History Museum's Earth Hall.

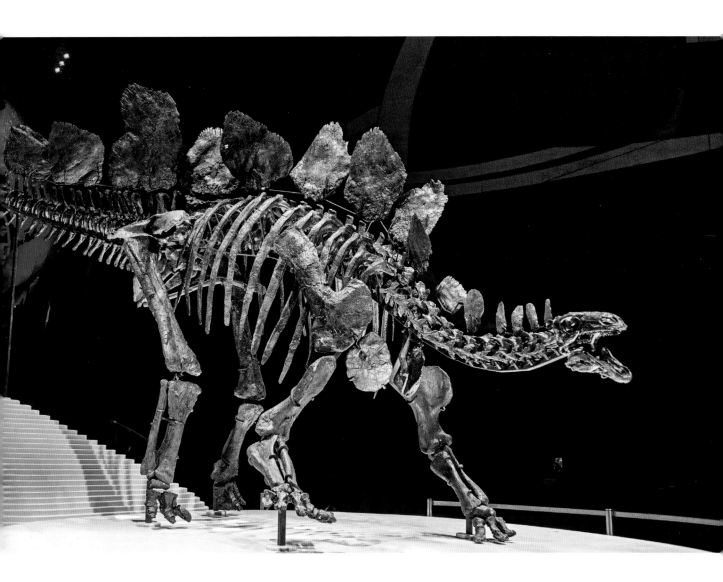

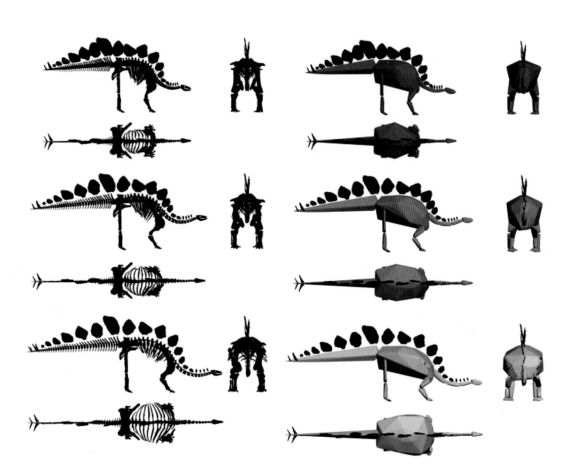

CHAPTER SIX

# THE SCIENCE OF SOPHIE

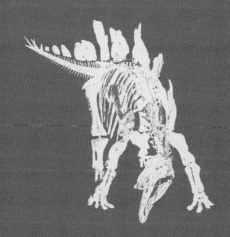

**SOPHIE CAN CLAIM** to be one of the most complete *Stegosaurus* specimens in the world – maybe the most complete. In addition, all of the bones have been fully removed from the rock that was encasing the skeleton, each is fully visible in three dimensions and none of the individual bones have been strongly deformed, so each retains its original shape and features. As a result, Sophie provides an ideal opportunity for learning more about the lifestyle of *Stegosaurus* and for updating our picture of this iconic, but surprisingly rare, dinosaur.

Various features of the skeleton, especially of the lower jaw, plates and vertebrae, show that Sophie belongs to a particular species of *Stegosaurus* –

**previous spread** Digital models of Sophie's skeleton.

**below** This diagram shows which parts of the skeleton are original and which are replicas. Although the skull on display is a replica, the original skull is in the museum's collections.

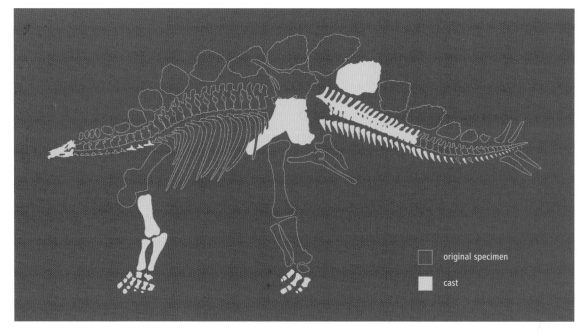

*Stegosaurus stenops*. To date, most of our information on *Stegosaurus stenops* has come from another well-preserved skeleton: that housed in the National Museum of Natural History, part of the Smithsonian Institution in Washington, D.C., USA. This skeleton is also substantially complete, but unlike Sophie remains partially encased in rock, which obscures some details of its anatomy. It is also slightly flattened and lacks a full set of back plates and tail spines, most of the tail and parts of the limbs. However, it does possess a complete, three-dimensional skull as well as most of the rest of the skeleton. A second substantially complete skeleton is housed in the Denver Museum of Nature and Science, but this has been squashed flat and is still partially hidden by rock: many details of its individual bones cannot be seen. Other skeletons, such as those belonging to a second species, *Stegosaurus mjosi*, are less complete than Sophie, the Smithsonian specimen or the Denver specimen.

Sophie's skeleton includes an almost complete skull and lacks only a few small bones from the lower jaw and the roof of the mouth. Prior to fossilization, as Sophie's carcass decayed, the many small bones that make up the skull and jaws became separated, so that each individual bone can be studied from every angle. Almost all of the backbone is preserved, and Sophie has a complete neck and back, and most of the tail. However, the first 20 of Sophie's tail vertebrae (those nearest to the hips) were too badly preserved to excavate, although they were originally present in the quarry. Almost all of Sophie's ribs are present, including the small ribs that lie alongside each of the neck bones, but many of the small bones that would have been present along the underside of the tail (called chevrons), which would have protected some of the nerves and blood vessels in the tail, are missing. Sophie's left arm was not preserved, but the right arm and both legs are substantially complete and several foot bones are also preserved.  Similarly, almost all of the hip bones and shoulder bones are present, although a couple of these are missing and may not have been fossilized. Finally, Sophie has the most complete set of

spines and plates found in any *Stegosaurus* specimen: only one plate appears to be missing and a complete set of four tail spines is available. For display purposes, replicas of each missing bone were made and added alongside the real bones of the skeleton. As the individual skull bones cannot be mounted due to their fragile nature, it was decided to put a replica skull on display and to keep the delicate skull bones in the Museum's dinosaur collection.

As no complete skeleton of *Stegosaurus* has ever been found, palaeontologists are slightly unsure of the total number of bones that would have been present originally. Based on Sophie and the other available specimens, it's likely that *Stegosaurus* had over 360 individual bones. With this number in mind, we can estimate Sophie's completeness. Sophie preserves around 65%, or almost two-thirds, of the bones in the skeleton. Although this number may seem low, most of the missing bones are small chevrons and toe bones that are all very similar to each to each other and make up only a tiny fraction of Sophie's body. If we think about Sophie's body as a whole, however, the only parts of the skeleton that are totally unknown are the hands, as no part of either hand was preserved in the quarry. The majority of dinosaur specimens consist only of isolated bones or small parts of skeletons, so a skeleton as complete as Sophie's has the potential to offer a huge amount of new scientific information.

Only a few scientists were able to work on Sophie's skeleton while it was stored in the Sauriermuseum prior to its arrival at the Natural History Museum. For example, Ragna Redelstorff and her colleague Martin Sander, based at the University of Bonn, Germany, were interested in how stegosaurs grew and decided to include Sophie in their analysis. Dinosaur growth can be studied in a surprising way: by looking at the details of their internal bone structure under a powerful microscope. As dinosaurs grow, they form new layers of bone that are laid down

around the edges of the existing bone, adding to their thickness and length. These new layers form rings within the bone during each annual growing season, forming a distinctive pattern that resembles tree rings. By slicing the bone open and counting the rings under a microscope, scientists can determine the age of the dinosaur. In addition, the type of new bone formed and the thickness of bone laid down between each new ring can provide information on how quickly the animal grew. Thick layers between rings with complicated patterns of bone structure suggest fast growth, whereas thinner layers with simpler, more organized bone structure indicate slow growth. In order to get the bone samples needed, Ragna and Martin drilled into some of Sophie's limbs and removed several thin cylinders of bone. These were then cut and polished until only thin slices remained, which could then be viewed under the microscope. They found that one of Sophie's arm bones had six growth rings, indicating a minimum age of at least six years, and maybe a little older (as bones grow some of the earlier growth rings become difficult to see). The type of bone present, and the thickness of each new layer, also showed that Sophie was still growing rapidly at the time of death. None of the features within the bones suggested that Sophie had reached final adult size, meaning that this particular *Stegosaurus* was a teenager or young adult when it died. Although only a teenager, Sophie is around 5.5 metres (18 feet) in length, and the top of the tallest back plate is approximately 3 metres (around 10 feet) above ground level. However, other *Stegosaurus* specimens indicate that a fully grown adult might have reached 9 metres (30 feet) in total length.

Following Sophie's arrival at the Natural History Museum, I assembled a scientific team to gather as much new information from the skeleton as possible, with the aim of using Sophie to update our knowledge of *Stegosaurus* and its relatives. The core scientific team was to consist of three members, led by me, the

museum's resident dinosaur researcher, a specialist in the fields of dinosaur feeding, classification and evolution. The second team member was Charlotte Brassey, an expert in biomechanics – the study of animal function. Charlotte was employed on the project for over a year and worked on Sophie full-time for that entire period. Charlotte was also selected for the team due to her familiarity with some of the technological approaches we planned to use in our work on the skeleton. Susannah (Susie) Maidment, from Imperial College London, was the final team member. Susie is the world's leading authority on *Stegosaurus* and other stegosaurs and is also a geologist who has studied the Morrison Formation sediments in which Sophie was found. As the other members of the Project Sophie team set about designing and building the new exhibition, we began the work of describing and analysing the skeleton. We planned to carry out several different studies on Sophie: descriptions of the skull and skeleton; an analysis of Sophie's body weight; some work on *Stegosaurus* leg muscles and movement; a computer-based analysis of feeding; and various projects on the functions of the plates and spines.

Charlotte's first task was to build a 3D virtual model of the skeleton that we could use for computer-based analyses of Sophie's biology. It would also prove useful for other team members, as it was helpful when designing the plinth for the skeleton and featured in a movie that now accompanies the exhibition. Two approaches were used to make this virtual model. Initially, Charlotte used a technique called photogrammetry. This involves taking photographs of each individual bone with a regular camera from as many different angles as possible, each including a scale bar to record the size of the bone. Around 40–50 shots of every bone in the skeleton were required for this approach – so Charlotte took over 20,000 photographs in total. The next step was to take the photographs for each bone and add them to a specialist computer package that took each 2D

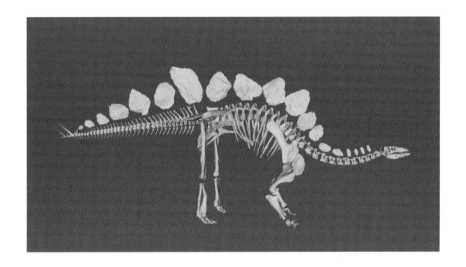

left Photographs and laser scans of each bone in the skeleton allowed us to build a virtual model of Sophie. This model was used to calculate body weight and to investigate muscles and movement.

image and combined them with all of the others, creating a 3D image. Once this had been completed Charlotte then used another piece of computer software to build all of these bones into a skeleton that showed all of the bones posed in their original positions. This painstaking work took several months to complete, but resulted in an exact virtual copy of Sophie's skeleton that was ready for use in other types of analysis.

In addition to photogrammetry, a second technique was used to image the skeleton. Just after work on Sophie had begun, the team was contacted by Jet Cooper, a special effects expert working at a company called Propshop, at the famous Pinewood Studios just outside London. Jet was a dinosaur enthusiast and had been working on some dinosaur models of his own, which led him to contact me. I was lucky enough to visit the Propshop headquarters at Pinewood and quickly realized that the equipment that they were using to build movie props would be

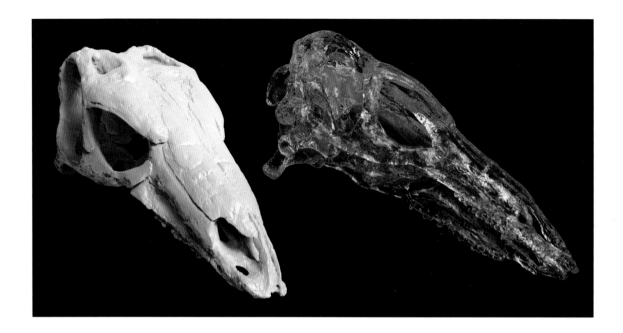

ideal for helping us with Project Sophie. Jet and his colleagues were keen to help us, and a Propshop team visited the museum with their 3D laser scanning equipment. Laser scanners are used to make highly accurate computer models of physical objects. They do this by shining a precision beam of laser light over the surface, and the way in which this light is reflected back into the scanner enables its software to build an exact virtual model of the object being scanned. Jet's team spent several days scanning the bones, with the scanner mounted on a large movable arm that could be rotated around the skeleton. The strip of laser light moving over the bones, together with the high-pitched warbling sound it made, made it seem like an instrument from a blockbuster science fiction movie! Working with Charlotte, the Propshop team made another virtual model of Sophie, which was used alongside Charlotte's photogrammetry model.

Propshop had another facility that they put at our disposal. To make movie props, they laser scan the objects needed and finish the design on computer. These

**above and opposite** These models of Sophie's skulls are based on CT scans that were used to make 3D prints. The blue area represents the space occupied by Sophie's brain cavity.

computer models are then printed in 3D, using special printers that use powdered plastic to recreate the computer model as a real three-dimensional object. Using their laser-scanned computer models of Sophie, Propshop were able to 3D print several of the individual bones. These were then included in the exhibition so that museum visitors could touch these exact replicas of Sophie's bones and gain an accurate impression of their size, shape and texture.

While Charlotte was creating virtual models of Sophie, Susie and I concentrated on a bone-by-bone description of the skeleton. We were interested in documenting as much anatomical detail as possible, so that we could double-check and update Charles Gilmore's century-old account of *Stegosaurus* anatomy. This work involved poring over each and every bone, making a series of painstaking measurements and writing long, detailed technical descriptions. As we worked, Susie and I compared our new observations with those of Gilmore and also took the opportunity to compare Sophie's bones with those from other stegosaur species, looking for differences and similarities between them. This work took several months, as each bone had to be examined and re-examined. Initially, we concentrated on the bones in the 'postcranial skeleton' – that is all of the bones other than the skull. This yielded a number of anatomical surprises and revealed unsuspected differences between *Stegosaurus* and other stegosaurs. For example, earlier reconstructions of *Stegosaurus* show the neck as fairly short, but Sophie helps to show that stegosaur necks were actually longer and more graceful than previously suspected. Differences between Sophie and other stegosaurs were found to be spread throughout the skeleton. Our new

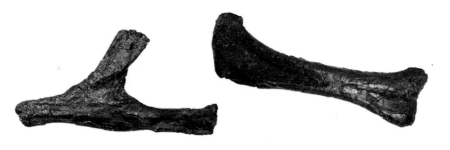

description of Sophie's postcranial skeleton has now been published in the scientific literature and provides a lengthy and detailed new update to Gilmore's classic paper.

Once Charlotte had completed the 3D virtual model of the skeleton, we started to use it to investigate Sophie's biology. Our first aim was to find out how much Sophie weighed when alive. This is an important question, as many aspects of a dinosaur's biology, such as how fast it could move, how much it needed to eat, and how often it might lay eggs, are closely related to body size. For example, very large animals tend to be slower, eat more and have fewer young than their smaller relatives. We used two methods to solve this problem. The first relied on Charlotte's model and used a technique called 'convex hulling'. This method involves taking the computer model of Sophie's skeleton and using specialist software to create a virtual skin, which is wrapped around the model. The virtual skin represents Sophie's external shape while alive (called the 'convex hull' of the skeleton, hence the name of the method). The skin is shaped to reflect not only the shape of the skeleton, but is also stretched in all of the right places to

**above** Detailed descriptions were prepared for every bone in the skeleton, including (from left to right) this neck rib, thighbone (femur) and tail bone (chevron).

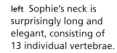

**left** Sophie's neck is surprisingly long and elegant, consisting of 13 individual vertebrae.

makes sure that it includes Sophie's missing soft parts, such as the shapes of the arm, leg and tail muscles, as well as the bulk of the belly. Once this 'skin' was in place, the computer package could then calculate the volume of the space inside Sophie's body. This body volume was then turned into body weight by multiplying it by the average density of Sophie's bones, muscles and organs. The convex hulling technique gave Sophie an estimated body weight of 1,560 kilograms (3,400 pounds) – around the same as a small rhinoceros. To double-check this answer, the team used a second, more traditional method – one based on some simple measurements of Sophie's leg and arm bones. Work on many living animals has shown that there is a strong relationship between the thickness of the leg bones and the body weight – the greater the body weight, the thicker and stronger the leg bones need to be. A simple mathematical equation relates these two measurements, and if one measurement is known it becomes simple to calculate the other. Once Sophie's age was taken into account, as this method is usually applied only to fully grown adults rather than teenagers/subadults like Sophie, this equation gave a body weight of around 1,800 kilograms (4,000 pounds) – very close to the estimate from convex hulling. Larger, fully adult individuals of *Stegosaurus* could be much heavier, however, potentially reaching up to 7,000 kilograms (15,500 pounds) in weight, around the same as an adult African elephant.

Sophie's skull offers important opportunities for research due to its completeness and excellent preservation. To allow detailed engineering analyses of skull function and to let us peer into the interior of the skull, we built detailed three-dimensional models of each individual bone using an instrument housed at the Museum called a computed tomographic (CT) scanner. CT scanners have many uses in medicine, engineering and biology and use X-rays to look at the internal features of bones (and other solid objects, such as machine parts). However, unlike

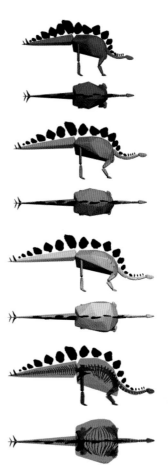

above Computer models of the skeleton were fleshed out with different amounts of muscle in order to calculate Sophie's body mass.

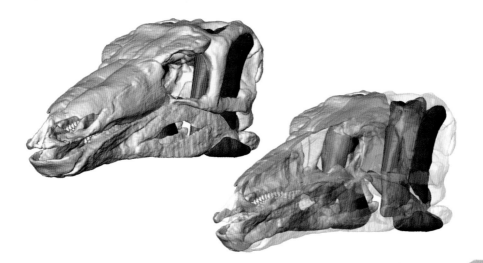

a conventional hospital X-ray machine, which provides the user with a 2D view of an object's interior, the CT scanner analyses the bone in three dimensions, providing much more information. These 3D images of the internal structure can then be analyzed using sophisticated computer packages to work out how these features might react to the various stresses and strains placed upon them when they're used for different functions. Together with another colleague, palaeontologist Stephan Lautenschlager, a specialist on dinosaur feeding behaviour, we re-assembled each of the individual 3D bone models into a combined virtual model of the complete skull – the first time that the skull had been fitted back together in 150 million years!

The team went on to use this virtual skull model to investigate chewing and feeding behaviour in *Stegosaurus*. We used information from living animals and the shapes of Sophie's skull bones to reconstruct the positions and sizes of the muscles that would have been responsible for opening and closing the jaws. This,

**above** Three dimensional models of Sophie's skull with reconstructions of the main jaw muscles attached.

left Charlotte checking through some of the CT scan images of Sophie's skull, in this case the part of the skull that houses the brain cavity.

in turn, allowed us to calculate how hard Sophie was able to bite. Our work showed that Sophie was able to generate a bite force similar to that of many living plant-eating mammals, such as cows and sheep. Although this may not sound very impressive (and it was certainly much weaker than the bite force of a lion, crocodile or *Tyrannosaurus*) it is actually a very high bite force for a herbivore. This was a complete surprise, as most palaeontologists had assumed that *Stegosaurus* should have had a very weak bite, as the teeth are so tiny and the jaws do not look like they were capable of strong chewing motions. We then added this information on bite force to our virtual skull model, and combined it with information on the strength of the skull bones, and how they are attached to each other. Using specialist engineering software, we were then able to deduce how the skull worked as a 'chewing machine' for the first time. This revealed how *Stegosaurus* gathered and processed its diet of plants and that the skull was built to resist the force of powerful, scissor-like bites. Previously, it was thought that *Stegosaurus* would have been limited to soft vegetation, such as ferns, but our new study suggests that it might have been able to feed on quite tough plants too, maybe including conifers and cycads. Similar analyses have already been

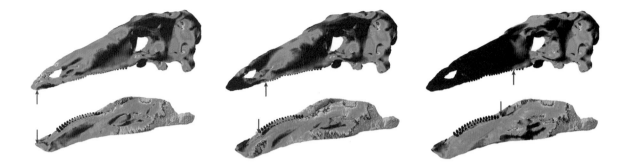

above These engineering models of Sophie's skull and lower jaw show how it became stressed and strained during biting. Cool colours are areas of low stress; hot colours are highly stressed.

carried out on other dinosaurs, and it seems that the skull of *Stegosaurus* functioned quite differently from those of other similarly-built plant-eaters, which were specialized for either rapid or very weak bites.

Other work on Sophie's skeleton remains to be completed, with various projects currently underway or planned for the near future. Plate function in stegosaurs has always been contentious among palaeontologists and, as Sophie has the most complete set of plates present in any *Stegosaurus*, we will use the skeleton to test some of these ideas. Sophie is ideal for this purpose, as 18 plates are preserved and gaps in the sequence suggest that only one is missing. In addition, the order of the plates can be reliably reconstructed thanks to the way in which the skeleton was preserved. One question the team hopes to answer relates to the strength of the plates and spines. Were they strong enough to be used for defence? In order to investigate this, one plate and one spine have been CT-scanned. We will use the same engineering software to work out the strength of Sophie's plates and spines, which will provide us with vital clues on how they were once used.

A final project relates to walking. Scars and other roughened surfaces on the skeleton reveal the positions of the large muscles needed to swing Sophie's arms and legs back and forth while walking. Another specialist computer package can be used to reconstruct these muscles on Charlotte's virtual model of the skeleton. This package can tell these muscles the order in which to work and how hard each of them should work during walking, These analyses will allow us to examine exactly

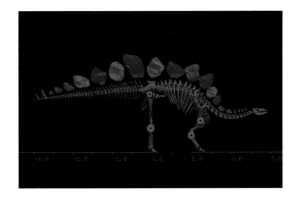 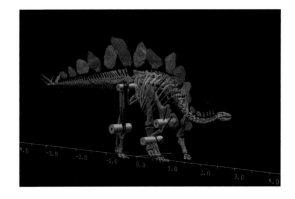

above Virtual muscles have been attached to these models of Sophie's skeleton as part of a project to understand more about walking in *Stegosaurus*.

how Sophie walked and how the walking performance of *Stegosaurus* compares with that of other animals, such as birds, crocodiles and other dinosaurs.

However, even after all of this work is completed, there are still many things about Sophie's life that we may never know. For example, we currently have no way of telling if Sophie was a male or a female – there are no known differences between the skeletons of male and female stegosaurs. The few clues that palaeontologists can use to sex dinosaurs, such as finding a special bone type associated with egg laying, or eggs within the body, cannot be used in Sophie's case – these pieces of evidence are not preserved. Moreover, we don't know why Sophie died. The skeleton shows no evidence of bite marks from a predator and none of the bones show signs of any major disease. Although one of Sophie's toe bones is badly damaged, possibly due to an infection, it seems unlikely that this would have caused the death of an otherwise healthy, large and fast-growing young adult. As the skeleton offers no clues on the cause of death it seems most likely that Sophie died either of starvation, one of the most common causes of death among wild animals today, or maybe of a disease affecting the organs that left no trace on the bones. Nevertheless, although we currently have no way of addressing these questions, it's entirely possible that future palaeontologists will invent new techniques that will allow them to solve these puzzles.

## POSTSCRIPT

Sophie has travelled far in time and space, journeying from the 150-million-year-old rocks of the Morrison Formation near Shell, Wyoming to the bustling crowds of present-day London. In addition to providing a stunning new exhibit in the Natural History Museum's Earth Hall, where the skeleton delights and inspires a new generation of visitors, Sophie is also unlocking some of the mysteries that have shrouded our knowledge of *Stegosaurus*. After millions of years in the ground and nearly a decade of excavation, preparation and study, Sophie's skeleton is now available for all to see. As new techniques to study dinosaurs become available, Sophie is likely to provide even more surprises for future generations.

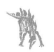

## ACKNOWLEDGEMENTS

Many people were involved in Project Sophie and in bringing the new *Stegosaurus* material to the Natural History Museum. These include special thanks to the donor, Mr Jeremy Herrmann and family, as well as the 69 other donors that contributed to the fund he established for the purchase, display and study of the specimen.

Critical information on the discovery, excavation and preparation of Sophie was provided by Bob Simon and Kirby Siber, Raimund Albersdoerfer helped arrange the transport and purchase of the specimen, and Brock Sisson built the frame and packed the specimen. The excavation (Ruedi and Priska Abbühl, Thomas Böttcher, Dimitri Brosens, Chris Keilmann, Kirby and Maya Siber, Bob Simons, Jeroen Vendericks, Beat von Arx, Esther Wolfensberger) and preparation (Jean-Claude Delaloye, Christina Egli, Toni Fürst, Esther Premru, Yolanda Schicker-Siber, Manuel Speck) teams are also thanked, as is the Red Canyon Ranch owner John Ed Anderson.

Charlotte Brassey (now at Manchester Metropolitan University), Susannah Maidment (now at the University of Brighton) and Stephan Lautenschlager (now at the University of Birmingham) each spent many hours working on the project, contributing their expertise on biomechanics and imaging, stegosaur evolution and dinosaur feeding mechanics, respectively.

Robert Nicholls was responsible for the two artworks of Sophie as a living animal. The Propshop team responsible for scanning Sophie included Jet Cooper, J. Enright, Amanda Darby, K. Squires and A. Walklate.

The Natural History Museum 'Project Sophie' team included: Lu Allington-Jones, Nina Barbaruk, Emma Bernard, Sandra Chapman, Marc Desmeules, Tim Ewin, Colin Farmiloe, Louise Fitton, Andy Fleet, Laura Fox, Mark Graham, Alan

Hart, Lisa Hendry, Jonathan Jackson, Beca Jones, Chloe Kembury, Simon Kershaw, Pooja Konjier, Wendy Ladd, Sarah Long, Nadia Lupo, Rachel Mackay, Martin Munt, Alison Purvis, Trista Quenzer, Joe Rodrigues, Nick Sainton-Clark, Anjali Singh, Helen Smith, Lorna Steel, Steve Suttle, Harry Taylor, Sally Weale and Jenny Wong. The Museum Director, Sir Michael Dixon, and the other members of the Executive Board (Neil Greenwood, Justin Morris, Ian Owens) gave their full support to the project team.

Finally, the author thanks Susannah Maidment for providing valuable comments that helped to improve an earlier draft and Trudy Brannan, Gemma Simmons and Colin Ziegler (NHM Publishing) for the opportunity to write this book.

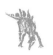

# FURTHER READING

Brett-Surman, Michael, Holtz Jr., Thomas R. and Farlow, James. *The Complete Dinosaur, Second Edition*. Indiana University Press, 2012.

Brusatte, Stephen. *Dinosaur Paleobiology*. Wiley-Blackwell, 2012.

Holtz Jr., Thomas R. *Dinosaurs: the Most Complete, Up-to-Date Encyclopedia for Dinosaur Lovers of all Ages*. Random House, 2007.

Naish, Darren and Barrett, Paul. Dinosaurs: *How they lived and evolved.* Natural History Museum, London, 2016.

Norman, David. *Dinosaurs: A Very Short Introduction.* Oxford University Press, 2005.

Paul, Gregory. *The Princeton Field Guide to Dinosaurs*. Princeton University Press, 2016.

Pickrell, John. *Weird dinosaurs: the strange new fossils challenging everything we knew.* Coumbia University Press, 2017.

## PICTURE CREDITS

Pages 6, 15, 42 (right), 43 © Dr Kirby Siber; p8-9 © Julius T. Csotonyi; p10 (top) © Ron Blakey, Colorado Plateau Geosytems, Inc.; p10 (bottom), 31 © Susannah Maidment; p11, 13, 40, 98 (top) © PLoS ONE; p12, 14, 14-15 (centre), 39, 41, 42 (left), 45 © Robert Simon; p16, 30 © Michael Rosskothen/Shutterstock.com; p26 map based on original map by PaleobioDB/FossilWorks; p27 © Sauriermuseum Aathal/Photo: Urs Moeckli; p29 © Museum fuer Naturkunde; p33 © Octávio Mateus; p50-51, 53 © Paul Barrett/The Trustees of the Natural History Museum, London; p52 © Becca Edwards; p54, 68-69, 83 © Robert Nicholls / The Trustees of the Natural History Museum, London; p57 © Herschel Hoffmeyer/Shutterstock.com; p60 © Courtesy of WitmerLab at Ohio University; p61 © Martin Lockley; p63, 66 © Heinrich Mallison; p88, 99 © Royal Society; p95, 103 © Charlotte Brassey for creation/The Trustees of the Natural History Museum, London; p100, 102 © Dr Stephan Lautenschlager/University of Bristol.

Every effort has been made to contact and accurately credit all copyright holders. If we have been unsuccessful, we apologise and welcome corrections for future editions. All other images are © The Trustees of the Natural History Museum, London.

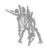